MEXICO CITY
architecture & design

Edited by Michelle Galindo
Concept by Martin Nicholas Kunz

teNeues

content

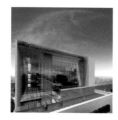

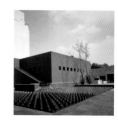

to see . culture & education

to see . public

to go . wellness, beauty & sport

to shop . mall, retail, showrooms

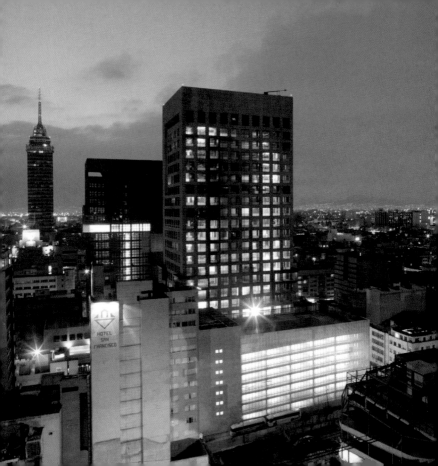

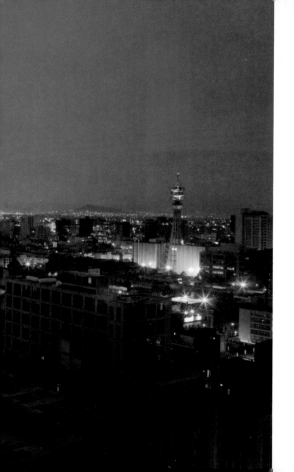

introduction

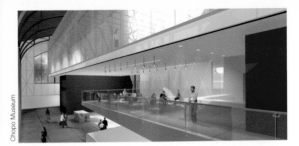

Chopo Museum

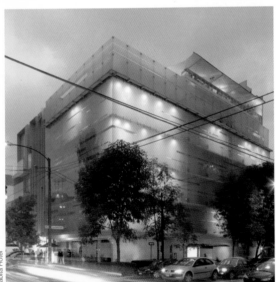

Habita Hotel

The capital lends itself as a laboratory in which urban conditions strongly influence work patterns and shape the architectural avant-garde. With more than 18 million inhabitants, and with 80 % of its area built without any professional intervention of architects or urban planners, Mexico City presents interesting conditions for those in search of a magic potion to unlock creativity. The synergy between the great architects of Mexico today such as: Higuera + Sánchez, LAR / Fernando Romero, Rojkind Arquitectos, amongst others, is presented here with renowned and unknown projects from the domestic scale to the mega metropolitan scale of Mexico City.

Die Hauptstadt ist ein Schmelztiegel und die in ihr gegebenen urbanen Voraussetzungen prägen die Arbeitsweise und kommen in der architektonischen Avantgarde zum Ausdruck. Mit mehr als 18 Millionen Einwohnern und einem Stadtgebiet, das zu 80 % ohne die fachkundige Mitwirkung von Architekten oder Städteplanern erschlossen worden ist, bietet Mexiko-Stadt all denen interessante Bedingungen, die auf der Suche nach der magischen Formel sind, die ihnen kreative Anstöße geben kann. Die Synergie zwischen den großen Architekten, die Mexiko heute prägen, wie u. a. Higuera + Sánchez, LAR / Fernando Romero und Rojkind Arquitectos, zeigt sich in berühmten und nie zuvor gesehenen Projekten, vom einfachen Wohngebäude bis hin zu Bauwerken in der Größenordnung einer Megastadt wie Mexiko.

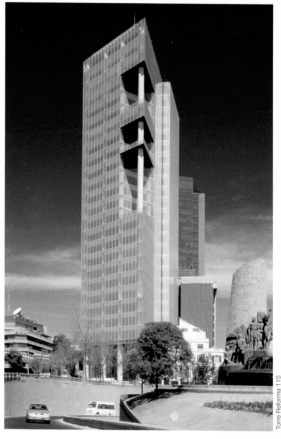

Torre Reforma 115

La capitale se présente comme un laboratoire où les conditions urbaines imprègnent le mode de travail et modèlent l'avant-garde architecturale. Avec plus de 18 millions d'habitants et 80 % de sa superficie développée sans l'intervention professionnelle d'architectes ou de développeurs urbains, Mexico présente des conditions intéressantes pour tous ceux qui cherchent la potion magique leur offrant la créativité. La synergie entre les grands architectes de Mexico aujourd'hui tels que Higuera + Sánchez, LAR / Fernando Romero, Rojkind Arquitectos, entre autres, se présente ici avec des projets réputés et inédits de l'échelle domestique à la grande échelle métropolitaine de Mexico.

La capital se presta como un laboratorio en donde las condiciones urbanas impregnan el modo de trabajar y moldean la vanguardia arquitectónica. Con más de 18 millones de habitantes y 80 % de su área desarrollada sin la intervención profesional de arquitectos o desarrolladores urbanos, la ciudad de México presenta condiciones interesantes para todo aquel que busque la poción mágica que le brinde creatividad. La sinergia entre los grandes arquitectos del México de hoy como la de: Higuera + Sánchez, LAR / Fernando Romero, Rojkind Arquitectos, entre otros se presenta aquí con proyectos renombrados e inéditos desde la escala domestica hasta la gran escala mega metropolitana de la ciudad de México.

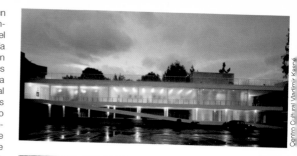

Centro Cultural Vladimir Kaspé

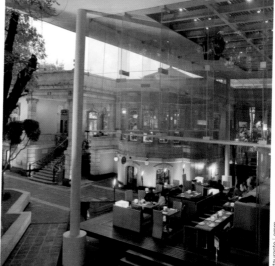

Restaurante Lamm

to see . living
 office & industry
 culture & education
 public

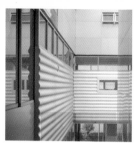
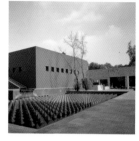
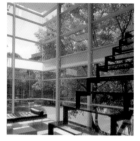
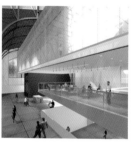

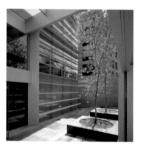
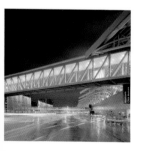
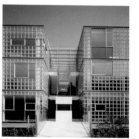
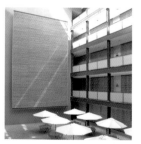

13 de Septiembre
Housing Complex

Higuera + Sánchez
Grupo SAI, Gerson Huerta, Roberto Sánchez (SE)

2004
13 de Septiembre
Escandón

www.higuera-sanchez.com

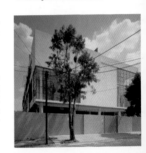

This project makes use of a pre-existing building that was home to a store of the Clothing and Team Workers' Cooperative Association, or "COVE" to house 37 units with flexible areas within a high-ceilinged building, illumination through large windows and cross-ventilation between the light well and the large window.

Dieses Projekt nutzte den bereits bestehenden Bau, ehemals ein Geschäft der Arbeitergenossenschaft für Bekleidung und Uniformen, „COVE", deren 37 Wohneinheiten über flexible Flächen mit sehr hohen Decken, durch große Fenster einfallendes Licht und eine gute Luftzirkulation zwischen Lichtschacht und Fenster verfügen sollten.

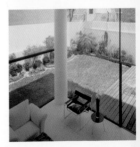

Ce projet exploite la construction préexistante qui abritait une boutique de la Société coopérative des costumiers et des équipementiers « COVE » pour que les 37 appartements aient des surfaces flexibles et un logement deux fois plus haut, un éclairage avec de grandes fenêtres et une ventilation croisée entre le cube de lumière et la fenêtre.

Este proyecto aprovechó la construcción preexistente que albergaba una tienda de la Sociedad Cooperativa de los Obreros de Vestuario y Equipo "COVE" para que los 37 departamentos tuviesen áreas flexibles en una vivienda de doble altura, iluminación con grandes ventanales y ventilación cruzada entre el cubo de luz y el ventanal.

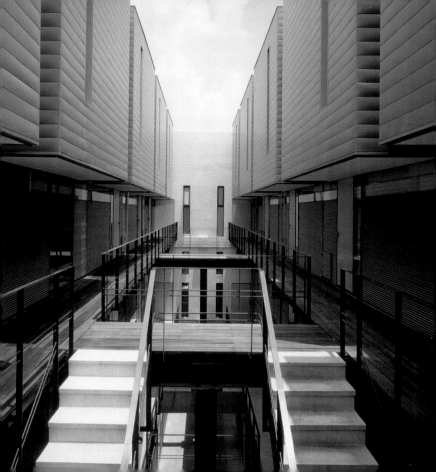

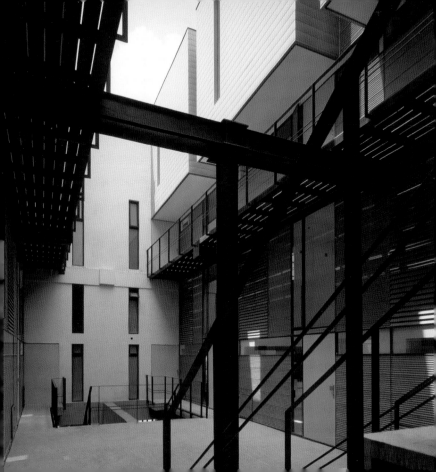

L8
Housing Complex

Archetonic, Arq. Jacobo Micha Mizrahi
CAFEL / Carlos Arroyo (SE)

2005
Laredo 08
Condesa

www.archetonic.com.mx

This complex is considerably more modern than its mid-rise neighbors. Two symmetrical structures are built along the site, housing a total of five apartments with 10 ft-high mezzanines.

Dieser Komplex ist deutlich moderner als die angrenzenden Immobilien mittlerer Höhe. Zwei symmetrische Körper entfalten sich über das gesamte Terrain und beherbergen insgesamt fünf Wohnungen mit 3 m hohen Zwischengeschossen.

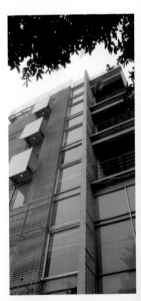

Ce complexe est nettement plus moderne que les immeubles contigues de hauteur moyenne. Deux structures symétriques se développent le long du terrain abritant un total de cinq appartements avec mezzanines de 3 m.

Este complejo es claramente más moderno que los inmuebles colindantes de mediana altura. Dos cuerpos simétricos se desarrollan a lo largo del terreno albergando un total de cinco departamentos con entrepisos de 3 m.

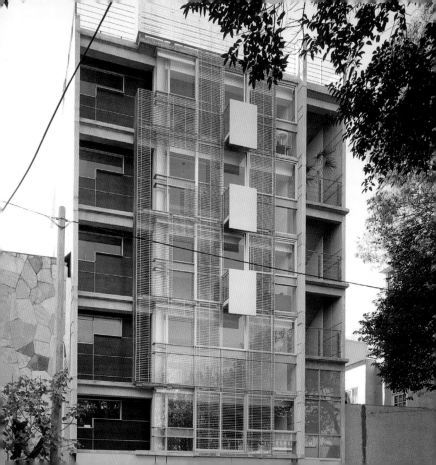

CH 90
Housing Complex

Archetonic, Arq. Jacobo Micha Mizrahi
DYS / Alejandro Fierro (SE)

2005
Cholula 90
Condesa

www.archetonic.com.mx

The design of this 30.5 ft glass box sought to respect the purest elements of a loft container. The spaces are created from an interior courtyard that penetrates the project right in the center, provoking the vertical link through a staircase.

Das Design dieses 9,30 m hohen Glaskastens behält den Gebäudetypus des Lofts in Reinform bei. Die Räume sind um einen Innenhof im Zentrum angelegt, der über eine Treppe eine Verbindung in der Vertikalen ermöglicht.

La conception de cette caisse de verre haute de 9,30 m s'attache à préserver l'aspect le plus pur d'un édifice de type loft. Les espaces sont créés à partir d'une cour intérieure qui perce le projet en plein cœur, provoquant le lien vertical par l'intermédiaire de l'escalier.

El diseño de esta caja de cristal de 9.30 m de altura se apegó a mantener lo mas puro de un contenedor tipo loft. Los espacios son generados a partir de un vació interior que penetra al proyecto justo en el centro, provocando la comunicación vertical a través de una escalera.

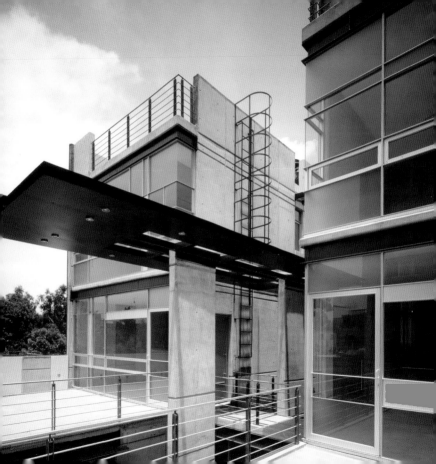

Ámsterdam + Sonora
Housing Complex

Central de Arquitectura

2003
Av. Ámsterdam / Sonora
Condesa

www.centraldearquitectura.com

These 26 apartments, set over seven levels, are the result of an intersection of volumes that respond to the urban necessities of the site. The flexibility of the space lends itself to various possibilities of interior arrangement; the apartments are set on one or two levels.

Diese 26 Wohneinheiten auf sieben Etagen sind das Ergebnis eines Grundrisses, der den städtischen Bedürfnissen der Gegend Sorge trägt. Die Flexibilität des Raums bietet verschiedene Möglichkeiten zur inneren Raumaufteilung der Wohnungen auf einer oder auf zwei Etagen.

Ces 26 appartements répartis sur sept niveaux résultent d'une intersection de volumes qui répondent aux nécessités urbaines de la région. La flexibilité de l'espace permet diverses possibilités d'arrangements de l'intérieur spatial, déterminant la répartition des appartements sur un ou deux niveaux.

Estos 26 departamentos en siete niveles son el resultado de una intersección de volúmenes que responden a las necesidades urbanas de la zona. La flexibilidad del espacio permite varias posibilidades de arreglo espacial interior, resolviendo los departamentos en uno o dos niveles.

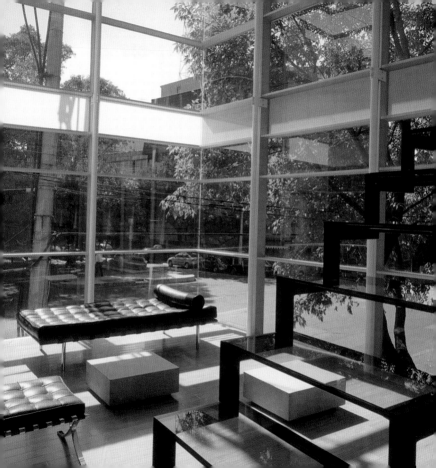

AR 58
Housing Complex

Dellekamp Architects, Derek Dellekamp
Ingeniería Integral Internacional (SE)

2003
Av. Alfonso Reyes
Condesa

www.dellekamparq.com

This introverted building has three façades exposed to variable and contrasting atmospheres. The façade was covered with two types of aluminum, one flat and the other wavy, in order to create different effects, reacting to light, changing the tone and creating shadows that reflect the movement from the street.

Die drei Fronten dieses introvertierten Gebäudes sind gegensätzlichen äußeren Bedingungen ausgesetzt. Die Fassade wurde mit zwei Aluminium-Arten überzogen, einer glatten und einer gewellten Schicht, die je nach Lichteinfall verschiedene Effekte erzeugen: Unterschiedliche Lichtverhältnisse verändern die Farben und erzeugen Schatten, die den Betrieb auf der Straße reflektieren.

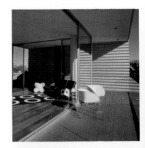

Cet édifice, de caractère introverti, possède trois côtés exposés à des atmosphères inégales et contrastées. La façade est recouverte de deux types d'aluminium, lisse et ondulé, visant à produire différents effets : réaction à la lumière, changement de ton et formation d'ombres reflétant le mouvement de la rue.

Este edificio, de carácter introvertido, tiene tres frentes expuestas a atmósferas desiguales y contrastadas. La fachada se recubrió con dos tipos de aluminio, una lisa y una ondulada, con el fin de crear diferentes efectos, reaccionando a la luz, cambiando el tono y generando sombras que reflejan el movimiento de la calle.

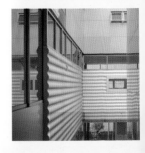

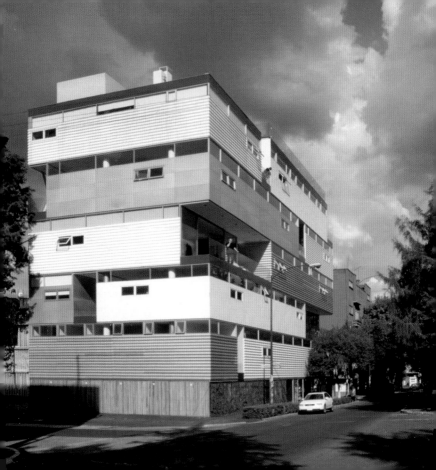

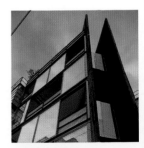

Chilpancingo 17
Housing Complex

Higuera + Sánchez
Colinas de Buen, S.A. de C.V. (SE)

2000
Chilpancingo 17 / Ámsterdam
Condesa

www.higuera-sanchez.com

Two black walls of exposed concrete are the starting point for these symmetrical, high-ceiling apartments. A duplex and a triplex apartment address the issue of privacy in the continuous glass façade with the use of a wire mesh as a railing, filtering views from the exterior.

Zwei schwarze Sichtbetonwände sind der Ausgangspunkt der symmetrischen Wohneinheiten mit sehr hohen Decken. Bei einer Duplex- und einer Triplexwohnung wird die Privatsphäre in diesem durchgehenden Glasbau durch ein Geländer aus Drahtgitter gewährleistet, das die Blicke von außen abfängt.

Deux murs noirs de béton exposés sont le point de départ des appartements symétriques à double hauteur. Un appartement en duplex et un appartement en triplex déterminent l'intimité en vitrine sans interruption avec une grille métallique de balustrade, filtrant les regards de l'extérieur.

Dos muros negros de concreto expuesto son el punto de partida de los departamentos simétricos de doble altura. Un departamento dúplex y un triplex resuelven la privacía en la vitrina sin interrupción con una malla metálica de barandal, filtrando las vistas del exterior.

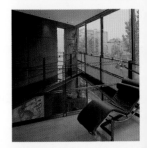

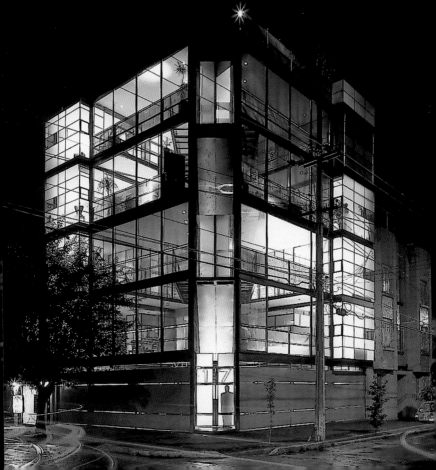

Parque España 47
Residential Building

TEN Arquitectos/Enrique Norten

2001
Parque España 47
Condesa

www.ten-arquitectos.com

Parque España is a paradigm of the loft concept. Six one-story lofts (excluding the double-story pent-house on the upper floor) extend towards the south by cantilevered terraces. The bedrooms are sheltered in the west elevation, keeping its privacy behind a slim balcony and translucent fabric.

Der Parque España ist exemplarisch für das Loft-Konzept. Sechs einstöckige Lofts (ausgenommen das Penthouse auf zwei Ebenen in der obersten Etage) erstrecken sich mittels ausladender Terrassen nach Süden. Die Zimmer befinden sich im westlichen Flügel und behalten mit einem schmalen Balkon und durchscheinendem Stoff ihre Privatsphäre bei.

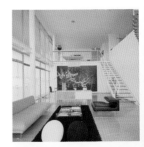

Parque España est un paradigme du concept du loft. Six unités réparties sur un niveau (à l'exception de l'appartement terrasse sur deux niveaux au dernier étage) s'étendent vers le sud au moyen de terrasses suspendues. Les chambres se réfugient dans l'élévation ouest, préservant leur intimité derrière un balcon étroit et un rideau translucide.

Parque España es un paradigma del concepto de loft. Seis unidades de un nivel (excepto el penthouse de dos niveles en el último piso) se extienden hacia el sur por medio de terrazas voladas. Las habitaciones se refugian en la elevación oeste, manteniendo su privacidad tras un balcón angosto y un tejido translúcido.

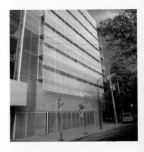

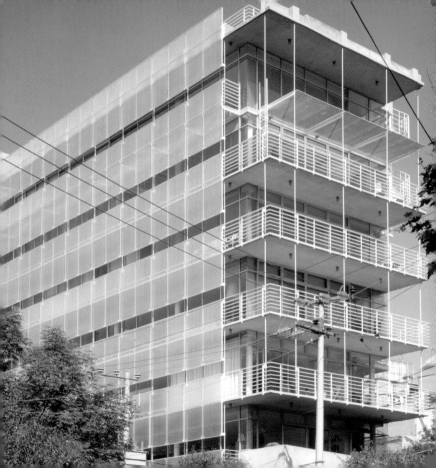

Casa Taanah Sak
Residence

BH / Broissin y Hernández de la Garza
(Gerardo Broissin, Jorge Hernández de la Garza)
PAICSA / Armando Aiza, Javier Montero (SE)

2006
Av. San Jerónimo Lt 38 Mz 2
San Jerónimo

www.broissinyhernandezdelagarza.com

This is a paradigm of the loft concept. To reflect the purity of the concept, the materials from its structure, concrete walls and steel elements, are completely exposed. In the upper floor, two rectangular masses with different heights provide the needed spaces to the private program, guiding the public spaces towards the terrace.

Dieses Gebäude stellt das Paradigma des Loft-Konzepts dar. Als Ausdruck der Stilreinheit sind die Materialien der Struktur – Betonmauern und Stahlelemente – komplett sichtbar. Im Obergeschoss verteilen sich Schlaf- und Badezimmer auf zwei rechteckige Räume von unterschiedlicher Höhe, während Wohn- und Esszimmer zur Terrasse hin ausgerichtet sind.

Il s'agit d'un paradigme du concept du loft. Pour refléter la pureté du concept, les matériaux de sa structure consistant en des murs de béton et en des éléments d'acier sont totalement exposés. A l'étage supérieur, deux espaces rectangulaires de plusieurs niveaux abritent les espaces privés, ce qui permet d'orienter les lieux publics vers la terrasse.

Este es un paradigma del concepto loft. Para reflejar la pureza del concepto los materiales desde su estructura con muros de concreto y elementos de acero están totalmente expuestos. En la planta alta dos volúmenes rectangulares con distintas alturas alojan los espacios privados, logrando orientar los públicos hacia la terraza.

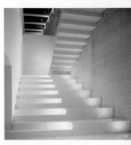

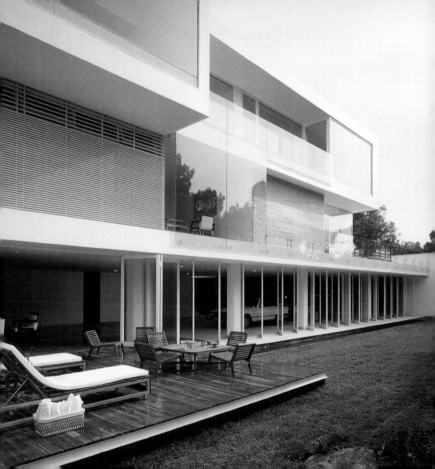

TEMP
Housing Complex

Archetonic, Arq. Jacobo Micha Mizrahi
CAFEL / Carlos Arroyo (SE)

2006
Anatole France 31
Polanco

www.archetonic.com.mx

The project is conceived of four structures, each separated from the others by patios and bridges. The two axes forming a cross function as the main point of access and distribution for the lofts.

Das Projekt ist in vier Einheiten aufgeteilt, die jeweils voneinander durch Innenhöfe und Brücken getrennt sind. Die beiden Achsen, die ein Kreuz bilden, dienen als Haupteingang und gliedern die Anordnung der Lofts.

Le projet compte quatre corps séparés les uns des autres par des cours et des ponts. Deux axes en forme de croix servent d'accès principal aux lofts et de répartition de ceux-ci.

El proyecto está concebido en cuatro cuerpos, cada uno separado de los demás por medio de patios y puentes. Dos ejes que forman una cruz sirven funcionalmente como acceso principal y distribución de los lofts.

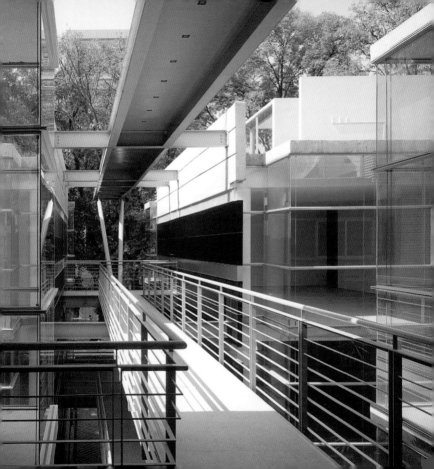

Dumas + Horacio
Housing Complex

Central de Arquitectura

2005
Alejandro Dumas 207
Polanco

www.centraldearquitectura.com

The building's expression is based on the use of a single material in the façade: the glass block. The physical characteristics of *vitroblock* (thermal and acoustic insulation, solar protection and bullet-proofed) allowed for different ambiences using a variety of transparencies and opacities.

Das Äußere dieses Gebäudes wird durch die Verwendung eines einzigen Materials an der Fassade bestimmt, dem Glasbaustein. Durch die physischen Eigenschaften von *Vitroblock* (Wärme- und Schalldämmung, Sonnenschutz und Schusssicherheit) konnten verschiedene Räume von unterschiedlicher Lichtdurchlässigkeit geschaffen werden.

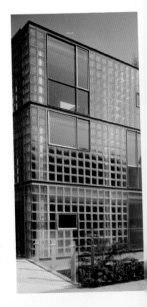

L'expression de cet édifice est fondé sur l'emploi d'un seul matériau en façade, le bloc de verre. Les caractéristiques physiques du *vitroblock* (isolant thermique et acoustique, protecteur solaire et blindé) ont permis de créer différentes ambiances avec des types distincts de transparence et d'opacité.

La expresión de este edificio está basada en el uso de un solo material en la fachada, el block de vidrio. Las características físicas del *vitroblock* (aislante térmico, acústico, protector solar y blindado) permitieron generar diferentes ambientes con distintos tipos de transparencia y opacidad.

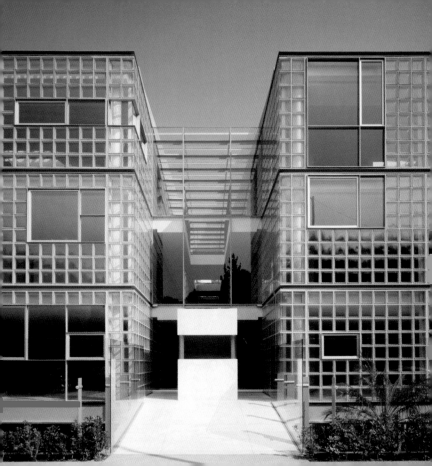

Conjunto Lafontaine
Housing Complex

Sánchez Arquitectos y Asociados
Colinas de Buen, S.A. de C.V. (SE)

2005
Calle Lafontaine 19
Polanco

www.sanchezarquitectos.com

The zoning laws of the Polanco neighborhood limited the construction of this small building to four-stories. The double amber façade facing the street generates a balcony and maximizes the view to the park.

Wegen der Bauauflagen für das Polanco-Viertel blieb dieses kleine Gebäude auf vier Etagen beschränkt. Die doppelte, bernsteinfarbene Fassade zur Straße hin verfügt über einen Balkon mit einem weiten Ausblick auf den Park.

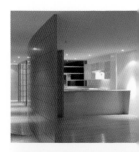

Les ordonnances du quartier de Polanco ont limité la construction de ce petit édifce sur quatre niveaux. La double façade de couleur ambre donnant sur la rue forme un balcon et maximise la vue sur le parc.

Las ordenanzas del barrio de Polanco limitaron la construcción de este pequeño edificio en cuatro niveles. La doble fachada de color ámbar hacia la calle genera un balcón y maximiza la vista hacia el parque.

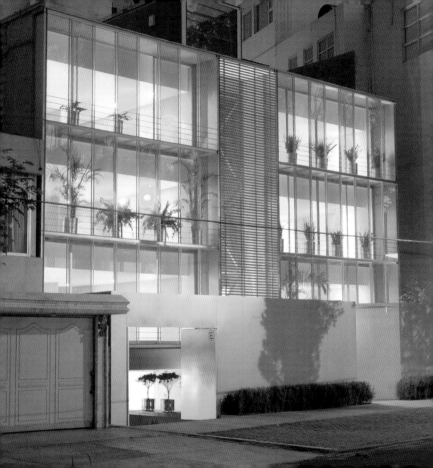

Casa pR 34
Residence

Rojkind Arquitectos, Michel Rojkind
MONCAD / Jorge Cadena (SE)

2003
Tecamachalco
Lomas de Chapultepec

www.rojkindarquitectos.com

This 1960s house required a re-design and an extension, an independent apartment for the client's daughter, a ballet dancer. The inspiration of the design resembled a dance between two bodies in motion. A tin-plated steel sheet of 0.20 in. in thickness envelops the structures which are divided in two half levels with separate access.

Dieses Haus aus den 60er Jahren wurde umgestaltet und um eine Wohnung mit einem eigenen Eingang für die Tochter des Kunden, eine Balletttänzerin, erweitert. Das Design wurde durch einen Tanz zweier Körper inspiriert. Eine 5 mm starke Stahlblechplatte umhüllt die Körper, die sich in zwei halbe Ebenen mit getrennten Eingängen aufteilen.

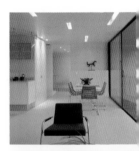

Cette maison des années 1960 a subi une rénovation et une extension, un appartement indépendant pour la fille du client, danseuse de ballet. La conception a été inspirée par une danse entre deux corps en mouvement. Une plaque d'acier étamée de 5 mm a enveloppé les corps, les séparant en deux niveaux moyens avec des accès séparés.

Esta casa de los años 60 ocupaba una remodelación y extensión, un departamento independiente para la hija del cliente, una bailarina de ballet. La inspiración del diseño se genero de un baile entre dos cuerpos en movimiento. Una placa de acero de 5 mm hojalateada envolvió a los cuerpos que se separan en dos medios niveles con accesos separados.

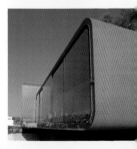

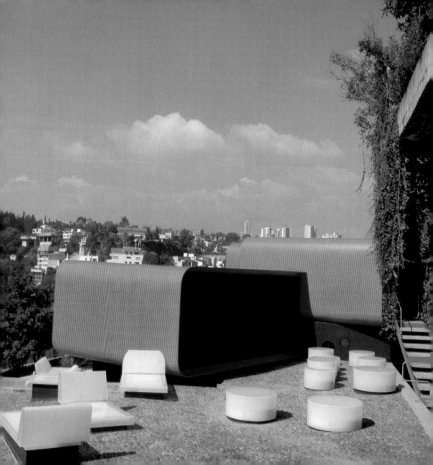

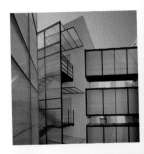

Ofelia 37
Housing Complex

Higuera + Sánchez

2003
Ofelia 37
San Ángel

www.higuera-sanchez.com

This small urban complex involved redefining the common spaces, giving priority to the communal areas and positioning the living spaces towards the south. The public and private areas are located in separate buildings, linked by floating glass bridges over the pedestrian walkway.

Das Wesen dieser kleinen städtischen Wohnanlage bestand in einem Neuentwurf des Gemeinschaftsplatzes, wobei die Gemeinschaftsbereiche betont und die Wohnungen nach Süden ausgerichtet wurden. Die öffentlichen und privaten Bereiche befinden sich in getrennten Gebäuden und werden durch Glasbrücken miteinander verbunden, die über die Fußgängerstraße führen.

Ce petit ensemble urbain consistait à repenser le lieu commun, privilégiant les parties communes et situant les logements vers le sud. Les zones publiques et privées se trouvent dans des édifices séparés intégrés au moyen de ponts vitrés suspendus sur la ruelle piétonne.

Este pequeño conjunto urbano consistió en replantear el lugar común; privilegiando a las áreas comunes y situando las viviendas hacia el sur. Las áreas públicas y privadas se encuentran en edificios separados integradas por medio de puentes acristalados volados sobre el callejón peatonal.

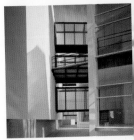

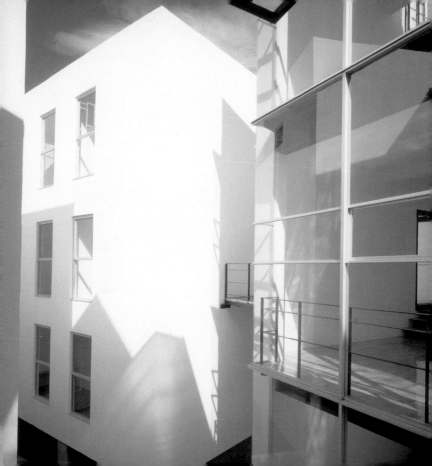

Children's Room

LCM / Fernando Romero
Iron. DOASA (SE)

2001
San Ángel

www.laboratoryofarchitecture.com

A children's room addition transformed the 1950s suburban home. The schematic design was born from a snail shell; an angular metal structure covered with polyurethane, using contemporary materials and emphasizing the interesting confrontation between the old and the new.

Der Anbau verwandelte diese Vorstadtwohnung aus den 50er Jahren. Dieser Raum für Kinder lehnt sich in seiner Form an ein Schneckenhaus an, seine winkelige Metallstruktur wurde mit Polyurethan überzogen. Durch die Verwendung moderner Materialien wurde ein interessanter Kontrast zwischen Alt und Neu geschaffen.

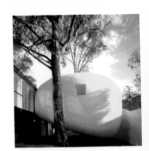

Cette construction additive a transformé la résidence suburbaine des années 1950. Cet espace pour enfants suit le schéma de la coquille d'un escargot ; sa structure angulaire métallique a été recouverte de polyuréthane, employant des matériaux modernes et accentuant un contraste intéressant entre le neuf et l'ancien.

Esta construcción añadida transformó la residencia suburbana de los años 50. Este espacio para niños tomo el esquema de la concha de un caracol; su angulosa estructura de metal fue cubierta con poliuretano, empleando materiales modernos y acentuando una confrontación interesante entre lo nuevo y lo viejo.

Hex-Towers (City Santa Fe)

Rojkind Arquitectos, Michel Rojkind
Juan Felipe Heredia (SE)

2009
Santa Fe

www.rojkindarquitectos.com

A structure that acts also as the façade of these volumes provides the necessary rigidity to be able to have open floor plans in the interiors. This complex, originating from an analogy between the roots of a large tree of life and the family unit, is able to house 180 apartments and a boutique hotel in a rigid and solid structure.

Eine Struktur, die zugleich als Fassade dient, verleiht dem Gebäude die erforderliche Festigkeit für die freien Stockwerke im Inneren. Dieser solide und gefestigte Komplex, als Analogie der Wurzeln eines Lebensbaumes und der Familie gedacht, besteht aus 180 Wohnungen und einem Boutiquehotel.

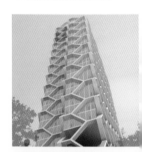

Une structure qui remplit à son tour la fonction de façade de ces espaces donne la rigidité nécessaire pour que les étages soient libres à l'intérieur. Ce complexe, né de l'analogie des racines d'un grand arbre de la vie et d'une unité familiale ferme et solide, comprend 180 logements et un hôtel-boutique.

Una estructura que actúa a su vez como fachada de estos volúmenes da la rigidez necesaria para poder tener plantas libres en su interior. Este complejo que nace de la analogía de las raíces de un gran árbol de la vida y de unidad familiar con su firmeza y solidez, contempla 180 viviendas y un hotel boutique.

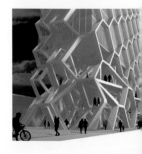

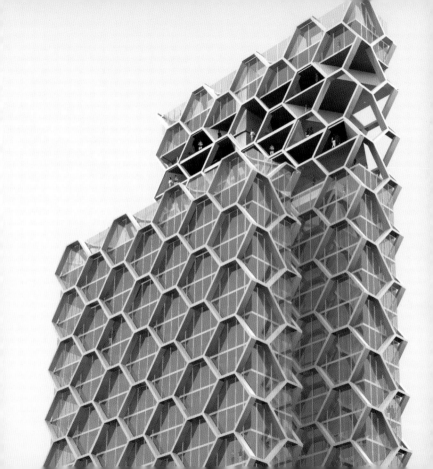

Teoloyucan
Low Income Housing

FRENTE arquitectura, Juan Pablo Maza
Grupo Modulo (SE)

2004
Calle Reforma / 13 de Junio
Barrio de Tlatilco, Teoloyucan

www.frentearq.com

The change of scales, colors and the play of proportions break the monotony of the mass-densification of these 60 houses. The speed with which it had to be built, characteristics and constraints in the approach of social housing complexes limit the design to a single house that is then replicated and mirrored.

Das Wechselspiel von Größenverhältnissen, Farben und Volumen bricht die Monotonie der massiven Dichte dieser 60 Häuser auf. Durch den Zeitdruck und die für den sozialen Wohnungsbau charakteristischen Einschränkungen in der Gestaltung blieb der Entwurf auf ein einziges Haus beschränkt, das sich danach wiederholt und das nachgeahmt wird.

Le changement d'échelles, les couleurs et le jeu de volumes rompent la monotonie de la densification massive de ces 60 logements. La hâte du temps de construction, les caractéristiques et les limitations de la conception d'ensembles d'intérêt social limitent la conception à une seule maison qui se reproduit par effet de miroir.

El cambio de escalas, colores y juego de volúmenes rompe la monotonía de la densificación masiva de estas 60 casas. La premura del tiempo de construcción, características y limitantes en el planteamiento de conjuntos de interés social limitan el diseño a una sola casa que después se repite y espejea.

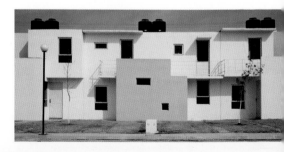

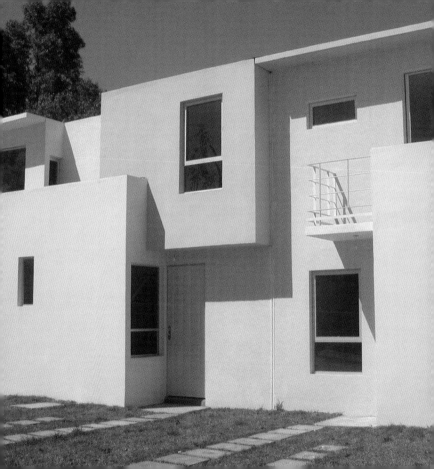

Edificio de Oficinas Justo Sierra 32
Office Building

Arquitectura 911sc

2003
Justo Sierra 32
Centro Histórico

www.arquitectura911sc.com

This intervention was jointed in two levels: the first floor and the roof-top. In the roof-top an existing structure was demolished to create a steel glass box, housing three offices that open up to internal patios. The glass box and the façade connect with each other to create a terrace.

Das Gebäude wurde in zwei Ebenen gegliedert, erste Etage und Dachterrasse. Auf der Dachterrasse wurde eine bestehende Struktur eingerissen, um einen Raum aus Stahl und Glas zu errichten, der drei Büros beherbergt, die alle zu Innenhöfen hin ausgerichtet sind. Glasraum und Fassade sind miteinander verbunden und bilden eine Terrasse.

Cette intervention a été articulée sur deux niveaux : étage et toiture-terrasse. Sur la toiture-terrasse, on a démoli une structure existante pour créer une caisse d'acier et de verre qui abrite trois bureaux donnant sur les cours intérieures. La caisse de verre attenant à la façade principale s'associe pour former une terrasse.

Esta intervención fue articulada en dos niveles: planta y azotea. En la azotea se demolió una estructura existente para crear una caja de acero y cristal que aloja tres oficinas que se abren hacia patios internos. La caja de cristal junto con la fachada principal se conecta para generar una terraza.

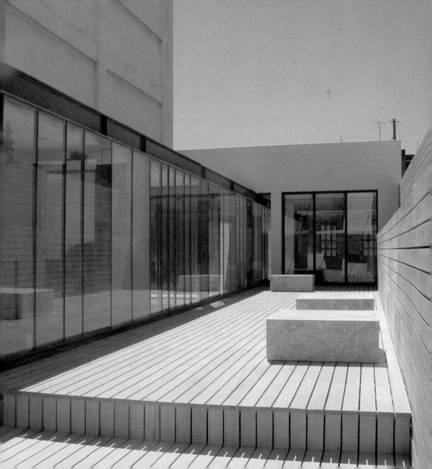

Centro Corporativo DIARQ
Corporate Building

Becker Arquitectos
(Arq. Moisés Becker, Humberto Ricalde, Benjamín Villeda)
Salvador Aguilar Reza (SE)

2002
Prado Sur 230
Lomas de Chapultepec

www.beckerarquitectos.com

The main volume of this corporate building consists of a porch with a glass pedestal and a main body reminiscent of classical architecture. A porch in the shape of a double T and two wide water mirrors enlarge the space of the square.

Das Hauptgebäude dieses Firmenkomplexes besteht aus einem Säulengang mit Glasfundament und einem Hauptkörper, der an klassische Architektur erinnert. Ein Säulengang in Form eines doppelten Ts und zwei große Wasserflächen erweitern den Platz.

Le volume principal de cet immeuble commercial se compose d'un portique avec soubassement vitré et d'un corps principal, de style classique. Un portique en double T et deux grands miroirs d'eau qui le reflètent agrandissent l'espace de la place.

El volumen principal de este inmueble corporativo consta de un pórtico con basamento acristalado y un cuerpo principal, de memoria clásica. Un pórtico en doble T y dos amplios espejos de agua que lo reflejan amplían el espacio de la plaza.

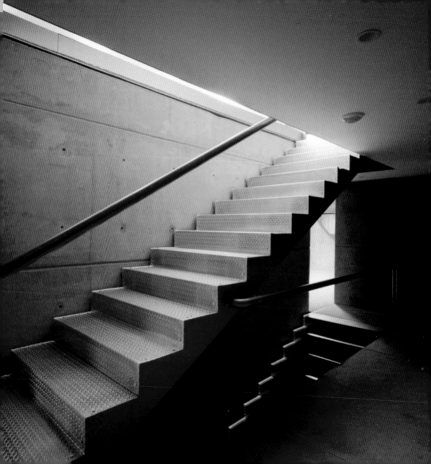

Corporativo Imagen
Corporate Building

Becker Arquitectos
(Arq. Moisés Becker, Humberto Ricalde, Benjamín Villeda)
Ing. Salvador Aguilar Reza (SE)

2000
Prado Sur 150
Lomas de Chapultepec

www.beckerarquitectos.com

The cubic volume of the building is covered by a membrane façade integrated to a glass curtain wall and aluminum mullions that protect it climatically. The plaza which slopes to its sides creates a transition between public and private space.

Das würfelförmige Gebäude ist von einer Fassadenmembran umgeben, die aus einem Glasvorhang und Mittelsäulen aus Aluminium besteht und so das Gebäude vor klimatischen Einflüssen schützt. Der an beiden Seiten geneigte Platz bildet einen Übergang zwischen dem öffentlichen und dem privaten Raum.

Le volume cubique de l'édifice est couvert d'une façade en membrane composée d'un rideau de verre et de meneaux en aluminium qui la protègent sur le plan climatique. La place inclinée sur les côtés crée une transition entre l'espace public et l'espace privé.

El volumen cúbico del edificio está cubierto por una fachada-membrana integrada por una cortina de vidrio y parteluces de aluminio que lo protegen climáticamente. La plaza que se inclina a sus dos costados crea una transición entre el espacio público y el privado.

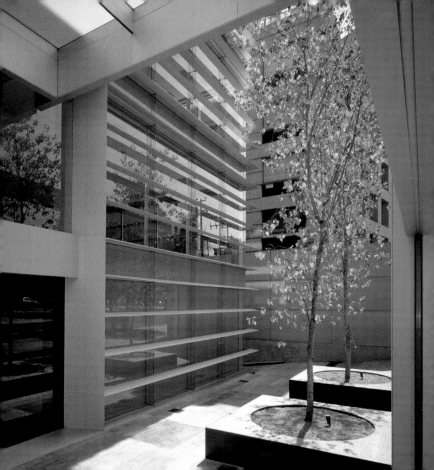

Torre Reforma 115
Corporate Building

Inmobiliaria Brom (Arquitectos Brom Asociados)

2005
Paseo de la Reforma 115
Lomas de Chapultepec

www.reforma115.com
www.inmobiliariabrom.com

The lightness of this corporate building is shown by its lightweight structure and a glass veil that protects the 23 office floors. The atmospheric conditions of the city favor terraced spaces and open interior gardens that are linked with the exterior.

Der Eindruck von Leichtigkeit dieses Firmengebäudes ergibt sich aus seiner Struktur und einem Glasschleier, der die 23 Büroetagen schützt. Die klimatischen Bedingungen der Stadt begünstigen Räume mit Terrassen und offene Gärten im Inneren, die über eine Verbindung nach außen verfügen.

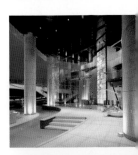

La légèreté de ce bâtiment destiné à des bureaux est exprimée au moyen d'une structure légère et d'un voile de verre qui protège les 23 étages de bureaux. Les conditions climatiques de la ville ont favorisé l'incorporation de terrasses, jardins intérieurs et ouverts, en les reliant à l'extérieur.

La ligereza de este edificio corporativo se manifiesta a través de su estructura ligera y un velo de cristal que protege a los 23 niveles de oficinas. Las condiciones climáticas de la ciudad propiciaron espacios con terrazas, jardines interiores y abiertos vinculándolos con el exterior.

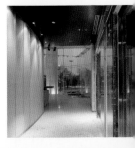

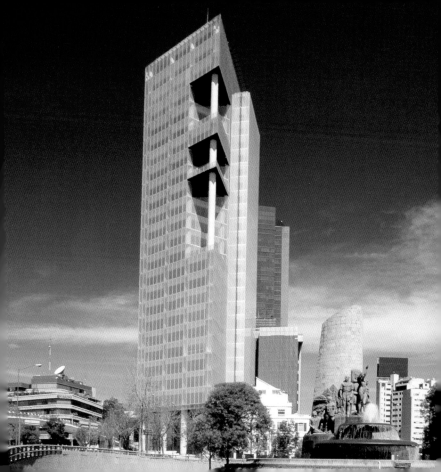

Glass Box Bank

LAR / Fernando Romero
Carrillo Ingenieros / Jesús Velasco (SE)

2002
Paseo de la Reforma 220
Lomas de Chapultepec

www.laboratoryofarchitecture.com

A deadline of 93 days to complete the design and project, together with the architects' interest in working with glass, determined the choice of material for this bank. To express the corporate values of Inbursa, a transparent but solid institution, different types of glass, filters, films and light were used on the façade.

Eine 93-Tages-Frist für Fertigstellung von Entwurf und Projekt sowie die Vorliebe der Architekten für Glas bestimmten das Baumaterial. Um die Firmenwerte von Inbursa widerzuspiegeln, einem transparenten wie soliden Unternehmen, wurden verschiedene Glasarten und Schichten sowie Filter eingesetzt und auf die Verwendung von Licht an der Fassade Wert gelegt.

Le délai de 93 jours qu'il a fallu pour achever la conception et le projet, ainsi que l'intérêt des architectes pour l'utilisation du verre a influencé l'emploi du matériau de ce banc. Pour exprimer les valeurs d'entreprise d'Inbursa, institution transparente mais solide, différents types de verre, de filtres, de couches et d'éclairage ont été employés sur la façade.

El plazo de 93 días para completar el diseño y proyecto, al igual que el interés de los arquitectos de usar vidrio determinó el uso de material de este banco. Para expresar los valores corporativos de Inbursa, transparente pero sólida como institución, diferentes tipos de cristales, filtros, capas y luz fueron empleados en la fachada.

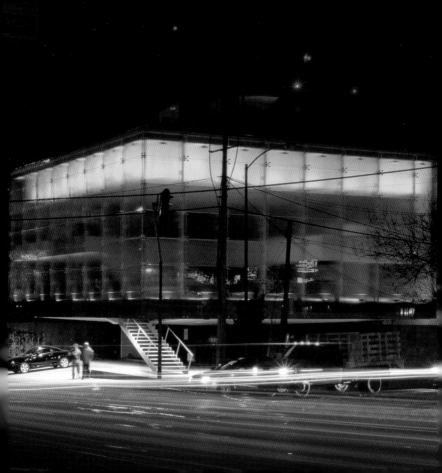

Inbursa Headquarters

LAR / Fernando Romero
Carrillo Ingenieros / Jesús Velasco (SE)

2002
Av. de las Palmas 736
Lomas de Chapultepec

www.laboratoryofarchitecture.com

The new two-story building has acquired a contemporary presence with its saturated blue surface on the exterior and internal transparency. This 300 ft-long building is exceeded in height by its surrounding office towers and is characterized by its intense urban presence.

Das neue, zweistöckige Gebäude erhält mit seiner satt-blauen Oberfläche außen und der Transparenz innen ein modernes Aussehen. Dieses 95 m lange Gebäude wird in der Höhe von den Bürotürmen der Umgebung überragt und hat in der Stadt eine starke Präsenz.

Le nouvel édifice de deux étages aquiert une présence contemporaine avec sa superficie saturée bleue à l'extérieur et sa transparence interieure. Cet ouvrage de 95 m de longueur est dépassé en hauteur par les tours de bureaux des environs et caractérisé par son intense présence urbaine.

El nuevo edificio de dos plantas adquiere presencia contemporánea con su saturada superficie azul por el exterior y transparencia interna. Este volumen de 95 m de largo es superado en altura por las torres de oficinas de su alrededor y caracterizado por su intensa presencia urbana.

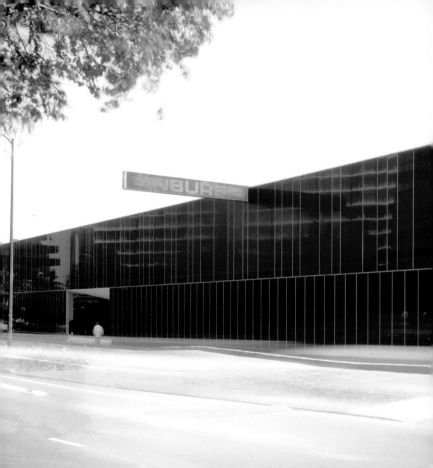

Corporativo Las Flores
Corporate Building

Jaime Varon, Abraham Metta, Alex Metta / Migdal Arquitectos
CTC—Ingenieros Civiles (SE)
CADAE Ingenieros—Carlos Álvarez (SE, structural adviser & supervisor)

2004
Blvd. Adolfo López Mateos 2009
Los Alpes

www.migdal.com.mx

This showcase building is visibly connected to the Periférico — one of the most important high-speed freeways in the city. Its magnificent façade uses tempered glass mullions to control the solar impact, defining the character of the horizontal façade.

Dieses Schaufenster-Gebäude ist sichtbar mit der Umgehungsstraße Periférico verbunden, einer der wichtigsten Stadtautobahnen. An der beeindruckenden Fassade fallen die Fensterkreuze mit Scheiben aus gehärtetem Glas ins Auge, mit denen die Sonneneinstrahlung kontrolliert wird und die der horizontalen Fassade ihren eigenen Charakter geben.

Cet édifice sous forme de vitrine est visiblement connecté au Periférico, l'une des voies à grande vitesse les plus importantes de la ville. Sa superbe façade présente des meneaux de verre trempé visant à contrôler l'incidence solaire, définissant le caractère de la façade horizontale.

Este edificio escaparate está conectado visiblemente con el Periférico, una de las vías más importantes de la ciudad y de alta velocidad. Su soberbia fachada hace uso de parteluces de cristal templado para controlar la incidencia solar, definiendo el carácter de la fachada horizontal.

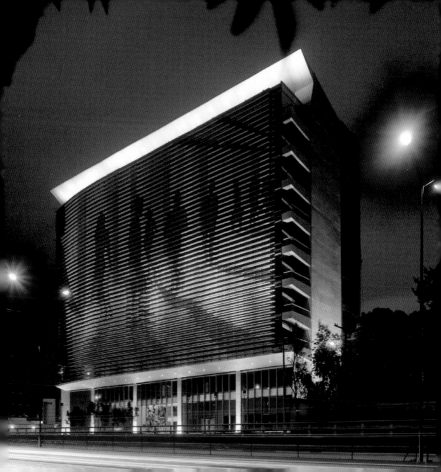

Torre Siglum
Corporate Building

Grupo de Diseño Urbano, Mario Schjetnan / José Luís Pérez
Álvaro Sánchez G. / Miguel Murguia (associate architects)

2000
Av. Insurgentes, Sur 1898
Florida

www.gdu.com.mx

This award-winning project, on the most important avenue in the southern part of the city, was planned as an urban landmark. The elliptical floor plan allows for uninterrupted views of the landscape, adding dynamism and continuity in perspective to the street movement.

Dieses preisgekrönte Projekt in der wichtigsten Straße im Süden der Stadt wurde als städtischer Meilenstein geplant. Das in elliptischer Form angelegte Gebäude bietet einen uneingeschränkten Blick auf die Landschaft, Dynamik und Kontinuität in der Perspektive und Bewegung im Straßenbild.

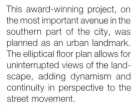

Ce projet primé dans l'avenue la plus importante du sud de la ville se présente comme une curiosité. Le plan de forme elliptique offre des vues ininterrompues sur le paysage, ajoutant dynamisme et continuité à la perspective et au mouvement de la rue.

Este galardonado proyecto en la avenida más importante del sur de la ciudad se proyectó como un hito urbano. La planta de forma elíptica permite vistas ininterrumpidas al paisaje, añadiendo dinamismo y continuidad en la perspectiva y movimiento de la calle.

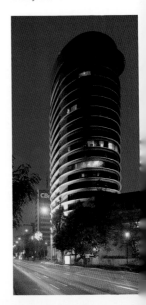

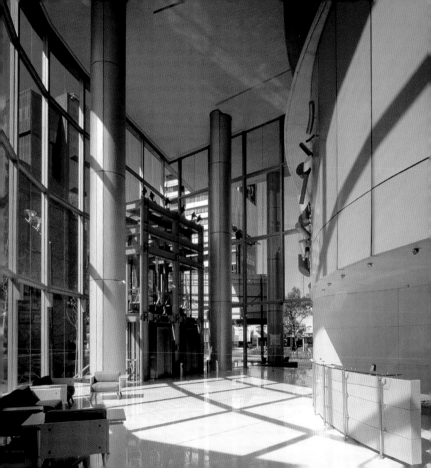

Corporativo Falcón
Corporate Building

Rojkind Arquitectos, Michel Rojkind
Dellekamp Architects, Derek Dellekamp
MONCAD / Jorge Cadena (SE)

2004
José María de Teresa
Tlacopac, San Ángel

www.rojkindarquitectos.com
www.dellekamparq.com

From the transformation of the ruins of three houses emerged an office building with an industrial aesthetic. A translucent material connects the interior with the exterior spaces, coloring the interior with orange light and creating a contrast with the grays of the interior.

Durch den Umbau der Ruinen dreier Häuser entstand ein Bürozentrum mit Fabrikästhetik. Ein durchsichtiges Material verbindet den Innen- und Außenbereich, taucht das Innere in ein orangefarbenes Licht und schafft einen Kontrast zu den Grautönen im Inneren.

La transformation des ruines de trois maisons a donné naissance à un centre de bureaux d'esthétique industrielle. Un matériau translucide relie les espaces intérieurs aux espaces extérieurs, colorant l'intérieur d'une lumière orange et créant un contraste avec les tons grisés de l'intérieur.

De la transformación de las ruinas de tres casas surgió un centro de oficinas de estética industrial. Un material translúcido conecta los espacios interiores con los exteriores, coloreando el interior con luz naranja y creando un contraste con los grises del interior.

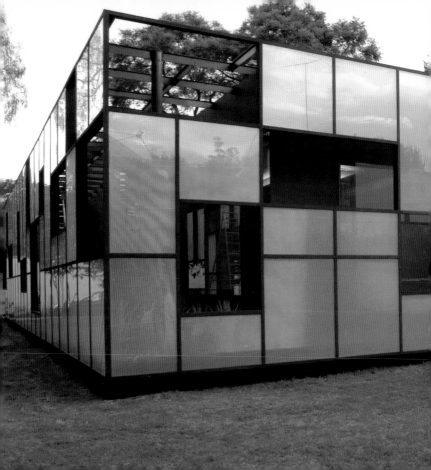

Torre Telefónica MoviStar
Office Building

Arditti+RDT arquitectos

2004
Av. Prolongación Reforma 1200
Santa Fe

www.ardittiarquitectos.com

The façade of the main volume consists of aluminum panels and the secondary one of prefabricated concrete panels that culminate by a glass curvature, defining the terraced areas in order to generate vertical movement in the main façade.

Die Außenhülle des Hauptgebäudes besteht aus Aluminiumpaneelen; das Nebengebäude aus vorgefertigten Betonpaneelen wird von einer Glaswölbung bedeckt, welche die mit einer Terrasse versehenen Räume markiert und so eine vertikale Bewegung in die Hauptfassade bringt.

L'enveloppe du volume principal est composée de panneaux d'aluminium et celle du volume secondaire, de panneaux préfabriqués en béton surmontés d'une courbure de verre, faisant ressortir les espaces en terrassement pour ainsi créer un mouvement vertical sur la façade principale.

La envolvente del volumen principal está compuesta por paneles de aluminio y el secundario por paneles prefabricados de concreto que se culminan por una curvatura de cristal, marcando a los espacios aterrazados para así generar un movimiento vertical en la fachada principal.

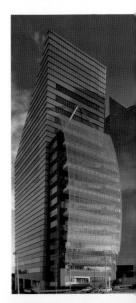

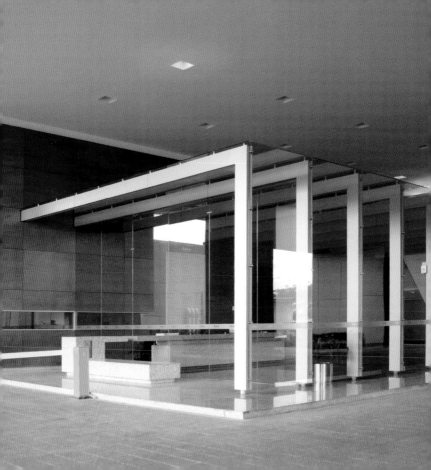

Corporativo Banorte
Office Building

Arditti+RDT arquitectos

2004
Av. Prolongación Reforma 1230
Santa Fe

www.ardittiarquitectos.com

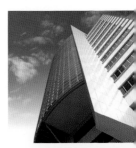

A sustainable design fuses together the three basic geometric shapes (triangle, circle and square) both in the floor plan and in the volume; the outer surface consists of a circular glass screen which houses partially covered terraces, creating natural shade.

Ein nachhaltiges Design vereinigt die drei geometrischen Grundformen (Dreieck, Kreis und Quadrat) sowohl im Grundriss als auch im Volumen. DIe Außenhaut besteht aus einer gebogenen Glashülle, unter der teilweise bedeckte Terrassen untergebracht sind, die so natürlichen Schatten erhalten.

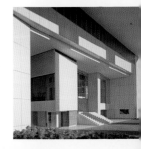

Une conception durable fusionne les trois formes géométriques de base (triangle, cercle et carré), aussi bien au niveau du plan qu'au niveau du volume ; l'enveloppe externe consiste en un écran de verre circulaire qui loge des terrasses à moitié découvertes pour créer un ombrage naturel.

Un diseño sostenible fusiona las tres formas geométricas básicas (triángulo, círculo y cuadrado) tanto en la planta como en volumetría; la piel externa consiste en una pantalla de cristal circular que aloja terrazas semi-descubiertas para generar un sombreado natural.

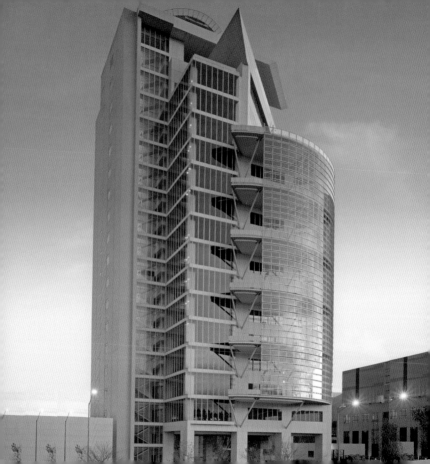

Centro de Cómputo Tlalpan
Computer Center

Jaime Varon, Abraham Metta, Alex Metta / Migdal Arquitectos
A.G. Ingenieros Civiles (SE)

1998
Calzada de Tlalpan
Santa Ursula Coapa, Coyoacán

www.migdal.com.mx

This recycled building has become a computer center for a bank, bringing together all that is needed to track its operations on a national level. The most characteristic elements are a corridor with glass surface that surrounds the functional areas and machines incorporating state-of-the-art technology.

Das bereits existierende Gebäude wird in ein Computerzentrum umgebaut, das über alle für eine auf nationaler Ebene operierende Bank notwendigen Einrichtungen verfügt. Die herausragenden Eigenschaften sind ein mit Glas ausgekleideter Flur, der die Betriebsräume umgibt, und Maschinen auf dem neuesten Stand der Technologie.

Cet édifice recyclé se convertit en un centre de calcul qui réunit tous les éléments nécessaires pour exécuter une fonction de banque nationale systématisée. Ce qui le caractérise particulièrement est le couloir périmétral vitré qui entoure les salles d'opération et les appareils de haute technologie.

Este edificio reciclado se convierte en un centro de cómputo que reúne todo lo necesario para ejecutar una función de banca sistematizada nacional. Los elementos más característicos son un pasillo perimetral acristalado que rodea las salas de operación y máquinas integrando la alta tecnología.

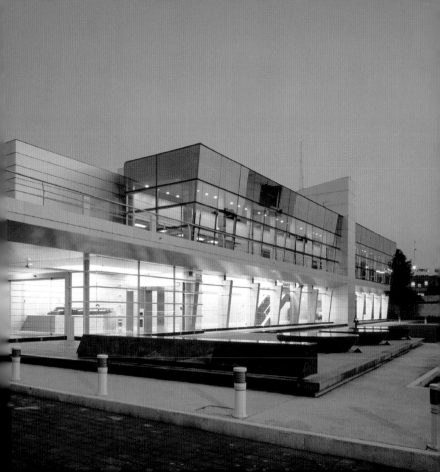

Química Delta
Chemical Distribution Center

Central de Arquitectura

1999
Carretera Teloyucan-Huehuetoco Bo,
Santa María Caliacac 259
Teloyucan

www.quidelta.com.mx
www.centraldearquitectura.com

Without the possibility of modifying the volumetric dimensions of the existing building, a floating glass box above an existing body of water of a hydroelectric plant defines its north façade with an exposed 16 in. concrete sheet, and the rest with a natural glass surface.

Ohne die Möglichkeit, die Form des bestehenden Gebäudes zu ändern, wurde ein Glaskasten konstruiert, der über dem Löschwasserteich eines Wasserkraftwerkes hängt und an der Nordseite mit einer 40 cm großen Sichtbetonplatte und an den übrigen Fassaden mit einer Haut aus Naturglas ausgestattet ist.

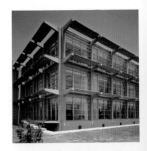

Sans possibilité de modifier le volume de l'édifice existant, une caisse de verre flottant au-dessus d'une centrale hydroélectrique existante, définit sa façade nord avec une plaque de 40 cm de béton apparent et les restes avec une peau de verre naturelle.

Sin la posibilidad de modificar la volumetría del edifico existente, una caja de cristal, flotada por encima de un estanque de aguas de emergencia existente de una central hidroeléctrica, define su fachada norte con una placa de 40 cm de concreto aparente y las restantes con una piel de cristal natural.

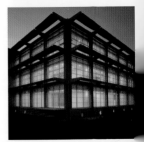

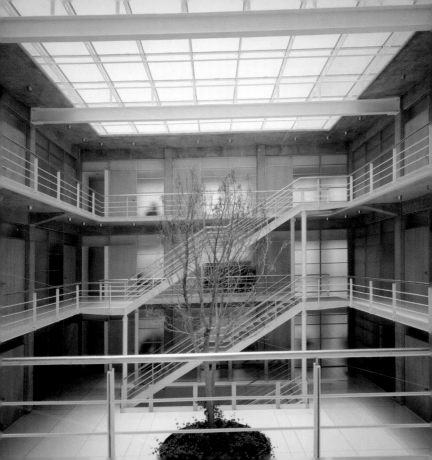

Centro Cultural Vladimir Kaspé
Cultural Center

BH / Broissin y Hernández de la Garza + Covarrubias
(Gerardo Broissin, Jorge Hernández de la Garza,
Gabriel Covarrubias González)
Fernando Castillo (SE)

2006
Universidad la Salle
Benjamín Hill / Av. Mazatlán
Condesa

www.broissinyhernandezdelagarza.com

Built on three levels, with a pedestal, body and culmination, the delicate glass box shelters the richness of the donated heritage by Vladimir Kaspé. A reinforced sheet of glass marks the access to the building, confines it from the immediate surroundings and accentuates the lightness and transparency of the wrap.

Dieses raffinierte, dreistöckige Glasgebäude mit Sockel, Baukörper und oberem Abschluss bewahrt das reichhaltige, von Vladimir Kaspé gestiftete Erbe. Leichtigkeit und Transparenz der Verkleidung werden mit einer verdickten Glasschicht akzentuiert, die den Zugang zum Pavillon markiert und diesen von der unmittelbaren Umgebung abgrenzt.

Formé de trois niveaux, à savoir le soubassement, le corps et le couronnement, cet édifice de verre raffiné protège la richesse du patrimoine offert par Vladimir Kaspé. La légèreté et la transparence de l'enveloppe sont accentuées par un gros plan de verre qui marque l'accès au pavillon et le sépare de l'entourage immédiat.

Conformado por tres niveles, a modo de basamento, cuerpo y remate, este delicado volumen de cristal resguarda la riqueza del acervo donado por Vladimir Kaspé. La ligereza y transparencia de la envolvente se acentúan con un plano engrosado de cristal que marca el acceso al pabellón y lo limita del entorno inmediato.

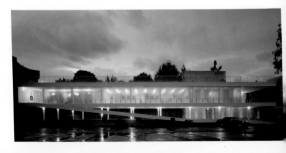

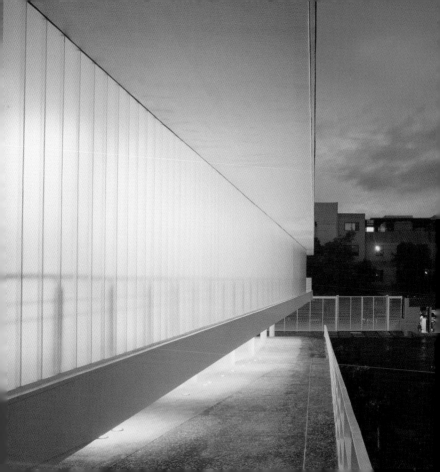

Eco Contemporáneo
Eco Experimental Museum Annexe

LAR / Fernando Romero
FRENTE arquitectura, Juan Pablo Maza

in process
Sullivan 49
San Rafael

www.laboratoryofarchitecture.com
www.frentearq.com

This experimental museum, designed by Mathias Goeritz 52 years ago, was in need of expansion. The winning proposal preserved the original heights and materials, achieving the discretion of the new building from the courtyard of the museum and thus creating a moderate transition between the existing buildings from Goeritz and Barragán.

Das experimentelle Museum, vor 52 Jahren von Mathias Goeritz geplant, musste erweitert werden. Der Siegervorschlag behielt die ursprünglichen Höhen und Materialien bei. Er erreichte eine gewisse Zurückhaltung des neuen Gebäudes gegenüber dem Museumshof und stellte so einen moderaten Übergang zwischen den Gebäuden von Goeritz und Barragán her.

Ce musée expérimental, dont le projet fut créé par Mathias Goeritz voilà 52 ans, avait besoin d'une extension. La proposition gagnante a conservé les hauteurs et les matériaux originaux, parvenant à la discrétion du nouveau bâtiment depuis la cour du musée tout en établissant une transition modérée entre les bâtiments de Goeritz et Barragán.

Este museo experimental, proyectado por Mathias Goeritz hace 52 años, requería una ampliación. La propuesta ganadora conservó las alturas y los materiales originales, logrando la discreción del nuevo edifico desde el patio del museo y estableciendo de esta manera una transición moderada entre los edificios existentes de Goeritz y Barragán.

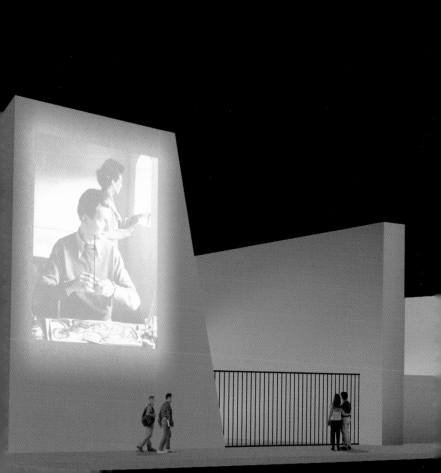

Chopo Museum

TEN Arquitectos/Enrique Norten

2006
Dr. Enrique González Martínez 10
Santa María la Ribera

www.chopo.unam.mx
www.ten-arquitectos.com

A structure from 1903 (originally built in Germany) has been brought back to life after its different institutional uses. The renovation consisted in interventions with transparent materiality—a new volume inserted into the structure and behind the existing façade, resulting in a linear design with exhibition areas and auditorium.

Die Struktur von 1903 (ursprünglich in Deutschland gebaut) hat schon verschiedenen Zwecken gedient. Bei der Renovierung wurden transparente Materialien verwendet. Ein Gebäude wurde neu in die bestehende Struktur und Fassade eingefügt, so dass eine lineare Ordnung mit Ausstellungsbereichen und einem Auditorium hergestellt wurde.

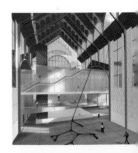

Une structure datant de 1903 (initialement construite en Allemagne) a repris vie depuis ses différents usages institutionnels. La renovation a consisté en des interventions de matériaux transparents, un nouveau volume intercalé dans la structure et la façade existantes, concevant un ordre linéaire avec des salles d'exposition et un auditorium.

Una estructura de 1903 (originalmente construida en Alemania) recobró vida después de sus diferentes usos institucionales. La renovación consistió en intervenciones de materialidad transparente; un volumen nuevo intercalado en la estructura y tras la fachada existente, concibiendo un orden lineal con áreas de exhibición y auditorio.

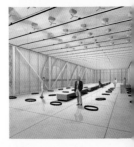

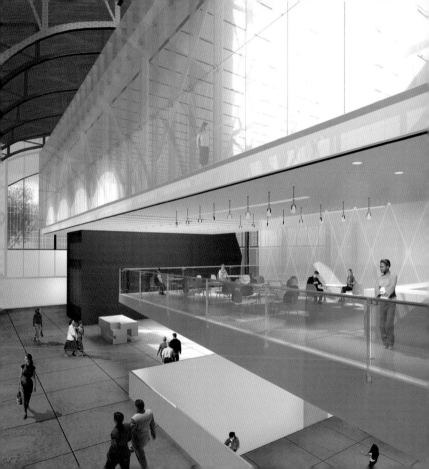

Biblioteca Vasconcelos
Library

Taller de Arquitectura X / Alberto Kalach

2006
Eje 1 Norte / Aldama
Buenavista

www.bibliotecavasconcelos.gob.mx
www.kalach.com

This mega-project does not just involve the expansion of the old Library of Mexico, but also a new concept that embraces different services within its five levels: an auditorium, a foreign language center, an on-site museum and a bookshop among other things, all surrounded by a large botanical garden.

Zu diesem Megaprojekt gehört nicht nur die Erweiterung der alten Bibliothek von Mexiko, sondern auch ein neues Konzept, das verschiedene Services auf fünf Ebenen umfasst: u. a. ein Auditorium, ein Fremdsprachenzentrum, ein Museum und eine Buchhandlung, all dies von einem sehr großen botanischen Garten umgeben.

Ce vaste projet envisage non seulement l'agrandissement de l'ancienne Bibliothèque de Mexico, mais aussi d'un nouveau concept qui englobe divers services à ces cinq niveaux : un auditorium, un centre de langues étrangères, un musée de site et une bibliothèque entre autres, tous entourés d'un long jardin botanique.

Este megaproyecto se trata no solo de la ampliación de la antigua Biblioteca de México, sino de un nuevo concepto que engloba distintos servicios dentro de sus cinco niveles: un auditorio, un centro de lenguas extranjeras, museo de sitio y librería entre otros, todo rodeado de un extenso jardín botánico.

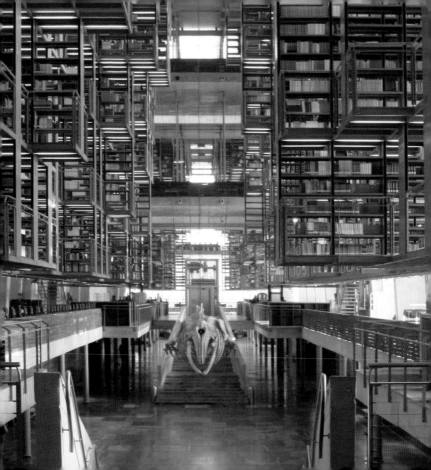

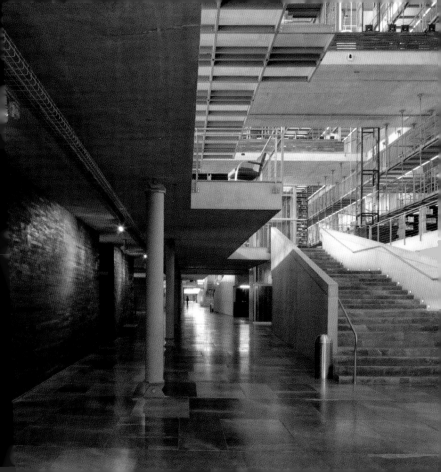

Museo Memoria y Tolerancia
Memory & Tolerance Museum

Arditti+RDT arquitectos

2006
Plaza Juárez / Luís Moya 12
Centro Histórico

www.ardittiarquitectos.com

This museum pretends to offer Mexico a space of study within a democratic and multicultural frame for the development of future generations. The main motif of the project is displayed with a functional suspended cube in the center of the lobby— creating a spectacular space in the interior and in the exterior.

Dieses Museum möchte Mexiko einen Raum für Studien geben, um in einem demokratischen und multikulturellen Rahmen die Entwicklung der nachfolgenden Generationen zu gewährleisten. Das Herz des Projekts ist ein Würfel, der mitten in der Lobby hängt, und der Teil der Museografie ist sowie einen eindrucksvollen Raum schafft, sowohl von innen als auch von außen.

Ce musée prétend donner à Mexico un espace d'étude et un cadre démocratique et multiculturel pour le développement des générations futures. Le cœur du projet est un cube flottant au milieu du vestibule, qui fait partie de la muséographie et offre un espace spectaculaire, aussi bien à l'intérieur qu'à l'extérieur.

Este museo pretende dar a México un espacio de estudio en un marco democrático y pluricultural para el desarrollo de próximas generaciones. El corazón del proyecto es un cubo que flota en medio del lobby, que forma parte de la museografía y logra un espacio espectacular, tanto en el interior del mismo como en el exterior.

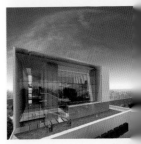

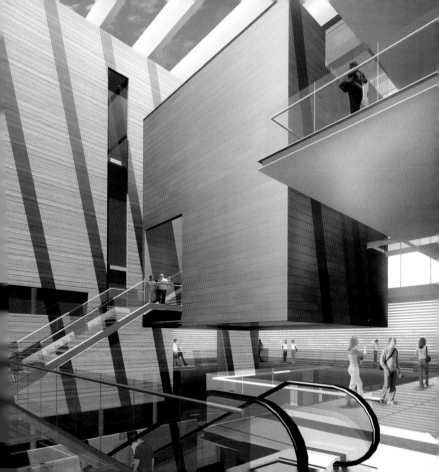

Centro Cultural de España en México
Cultural Center

Arquitectura 911sc

in process
República de Guatemala 18
Centro Histórico

www.ccemx.org
www.arquitectura911sc.com

An existing structure of approximately 66 ft x 66 ft of floor space and 25 ft in height has been brought back to life as a gallery and an indoor plaza. It is a place to exhibit large sculptures, installations, and for dance shows or alternative media.

Einer bereits bestehenden Struktur wird neues Leben eingehaucht. Auf einer Grundfläche von etwa 20 m x 20 m und einer Höhe von 7,50 m sind eine Galerie und ein Innenhof entstanden, ein Ort, an dem großformatige Skulpturen und Installationen ausgestellt sowie Tanz- oder andere Aufführungen dargeboten werden können.

Une structure existante d'environ 20 m x 20 m à l'étage et d'une hauteur libre de 7,50 m, à la fois galerie et cour intérieure, reprend vie. C'est un lieu d'exposition de la sculpture de grand format, de l'équipement et des spectacles de danse ou de médias alternatifs.

Una estructura existente de aproximadamente 20 m x 20 m en planta y una altura libre de 7.50 m vuelve a cobrar vida, es a la vez galería y plaza interior. Es un lugar para exhibir escultura de gran formato, instalación y espectáculos de danza o medios alternativos.

Museo de Arte Popular
Museum of Popular Art

Teodoro González de León
Jorge Agostoni (Museographer)
Colinas de Buen, S.A. de C.V. (SE)

2006
Revillagigedo 11 / Independencia
Centro Histórico

www.map.org.mx

The old headquarters of the Fire-fighters and Police Station now houses an area for the exhibition, diffusion and research of the Mexican craft work. In its intervention contemporary elements were incorporated, such as a helicoidal staircase in the tower and a large glass dome on the central courtyard.

Der alte Sitz der Feuer- und Polizeiwache beherbergt jetzt einen Raum zur Ausstellung, Verbreitung und Erforschung des Handwerks in Mexiko. Beim Umbau wurden moderne Elemente eingeführt, etwa eine Wendeltreppe im Turm und eine große Glaskuppel im Innenhof.

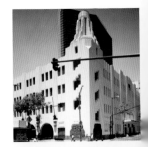

L'ancien siège de la Caserne des Pompiers et de la Police accueille maintenant un espace destiné à l'exposition, la diffusion et la recherche axées sur le travail artisanal du Mexique. Des éléments contemporains ont été introduits lors de son adaptation, par exemple un escalier hélicoïdal dans la grosse tour et un grand dôme en verre dans la cour centrale.

La antigua sede de la Estación de Bomberos y Policía ahora aloja un espacio para la exhibición, difusión, e investigación del trabajo artesanal de México. En su intervención se introdujeron elementos contemporáneos, como una escalera helicoidal en el torreón y un gran domo de cristal en el patio central.

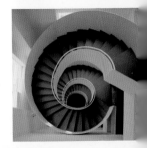

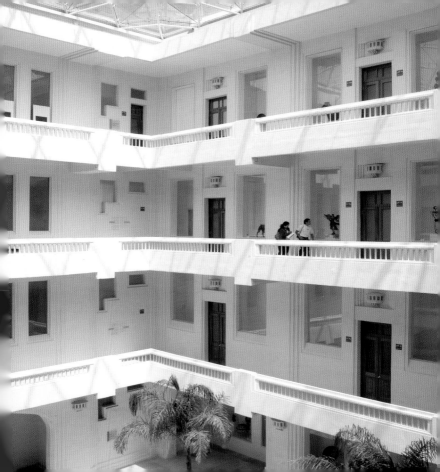

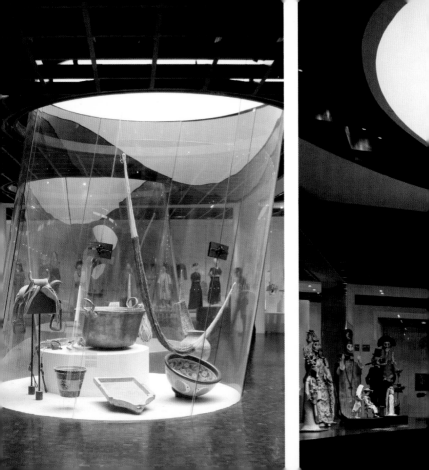

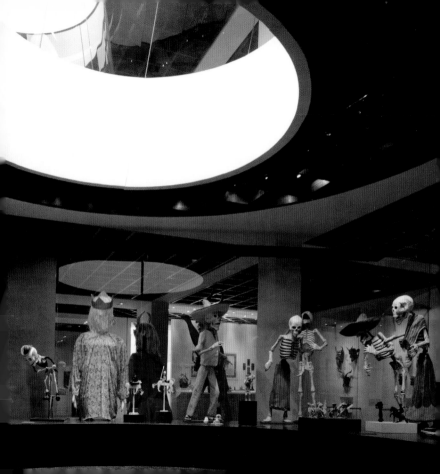

El Papalote Museo del Niño
Children's Museum

Legorreta + Legorreta
Raúl Izquierdo (SE)

1993, 2003
Av. Constituyentes 268
Ampliación Daniel Garza

www.papalote.org.mx
www.legorretalegorreta.com

This 260,000 sqft museum invites children to art and learning. Its size and volume were composed of understandable forms, colors and materials to stimulate children's imagination and fantasies without intimidating them. In a second phase a planetarium was added with a hemispheric screen of 75 ft in diameter.

In diesem Museum soll Kindern auf 24.000 m² Raum für die Kunst und zum Lernen gegeben werden. In den Räumlichkeiten wurden leicht verständliche Formen, Farben und Materialien verwendet, welche die Fantasie der Kinder anregen sollen, ohne sie einzuschüchtern. In der zweiten Phase wurde ein Planetarium mit einem halbkugelförmigen Bildschirm von 23 m Durchmesser hinzugefügt.

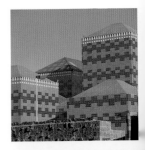

Ce musée de 24 000 m² invite les enfants à l'art et à l'apprentissage. Sa taille et son volume ont été composés de formes, de couleurs et de matériaux faciles à comprendre, en vue de stimuler l'imagination et les fantaisies des enfants sans les intimider. Au cours de la deuxième étape on a ajouté un planétarium avec un écran hémisphérique de 23 m de diamètre.

Este museo de 24,000 m² invita a los niños en el arte y aprendizaje. Su tamaño y volumen fueron compuestos de formas, colores y materiales fáciles de comprender, para estimular la imaginación y las fantasías de los niños sin intimidarlos. En la segunda fase se añadió un planetario con una pantalla hemisférica de 23 m de diámetro.

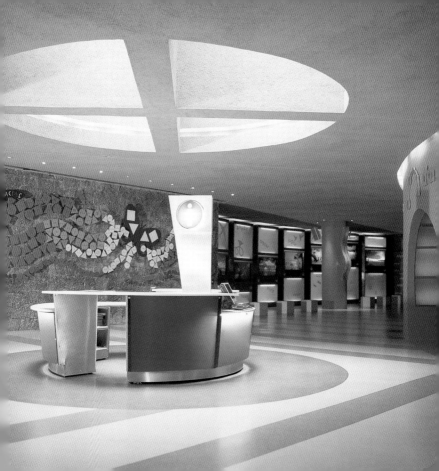

Videoteca Nacional Educativa
National Educational Video Library

Adria+Broid+Rojkind (Miquel Adria, Isaac Broid, Michel Rojkind)
Salvador Mandujano (SE)

2000
Canal de Miramontes
Coyoacán

www.rojkindarquitectos.com

An innovative design solution integrates and enhances the character of the new broadcasting center and archive for information and video images; establishing a perceptive ambiguity with a translucent tattooed-glass skin over the naked skeleton.

Eine innovative Designlösung hebt den Charakter des Gebäudes hervor und integriert ein neues Sendezentrum sowie ein Informations- und Video-Archiv. Es wird eine ambivalente Wahrnehmung erzeugt, indem auf dem nackten Skelett eine durchsichtige, bedruckte Glasschicht angebracht wurde.

Une conception innovante compose et rehausse à la fois le caractère de l'édifice du nouveau centre d'émissions et d'archives d'information et d'images vidéo, établissant une ambiguïté perçue avec un verre translucide tatoué sous le squelette à découvert.

Una innovadora solución de diseño integra y realza a la vez el carácter del edificio del nuevo centro de emisiones y archivo de información e imágenes en video. Estableciendo una ambigüedad perceptiva con un vidrio translúcido tatuado sobre el esqueleto al descubierto.

94

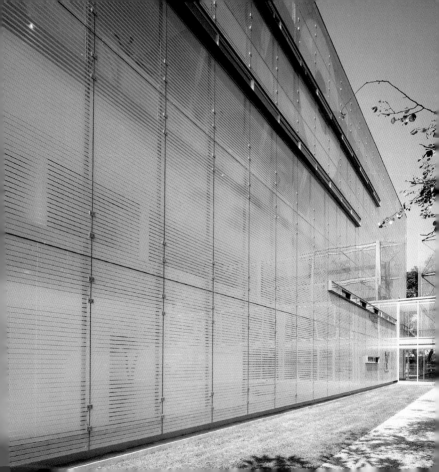

Torre de Ingeniería UNAM
Engineering Building in UNAM (University)

Sánchez Arquitectos y Asociados
Colinas de Buen, S.A. de C.V. (SE)

2005
Ciudad Universitaria
Coyoacán

www.iingen.unam.mx
www.sanchezarquitectos.com

The premise of the project was to provide a dialogue and a counterpoint that could define the 50 years that have passed from the original campus to the new building. To exhibit the engineering process of the building, the installations are run through pipelines, offering economy and functionality.

Die Prämisse des Projekts bestand darin, einen Dialog und einen Kontrapunkt zu bieten, der die 50 Jahre Abstand zwischen dem Originalcampus und dem neuen Gebäude definiert. Zur Darstellung der technischen Vorgänge im Gebäude verlaufen die Installationen durch Pipelines, die Wirtschaftlichkeit und Funktionalität veranschaulichen.

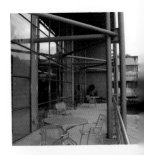

La premise du projet consistait à offrir un dialogue et un contrepoint définissant les 50 années séparant le campus original du nouvel édifice. Pour exposer le processus ingéniorial de l'édifice, les installations se trouvent dans des canaux, offrant ainsi économie et fonctionnalité.

La premisa del proyecto constituyó en ofrecer un diálogo y un contrapunto que definiera los 50 años de distancia entre el campus original y el nuevo edificio. Para exponer el proceso ingenieril del edificio las instalaciones corren en ductos, ofreciendo economía y funcionalidad.

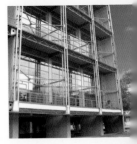

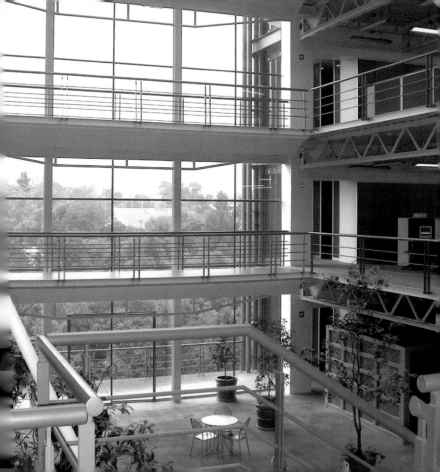

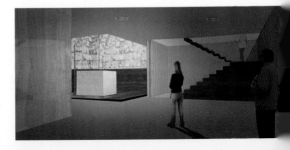

Capilla Imdosoc
Chapel

Arquitectura 911sc

in process
San Ángel

www.arquitectura911sc.com

In addition to being a chapel, this project has a library and classrooms for the school adjoining this site. Its geometry and large windows enable light to flood in dynamically, prevailing in the space and restoring the tranquility needed for its proper use and meditation.

Dieses Projekt ist nicht nur eine Kapelle, sondern verfügt auch über eine Bibliothek und Klassenzimmer für die nebenan liegende Schule. Seine geometrische Struktur und die Fenster ermöglichen einen dynamischen Lichteinfall, der dem Raum die erforderliche Ruhe für seine Zwecke gibt, z. B. für die Meditation.

Outre une chapelle, ce projet dispose d'une bibliothèque et de salles de classe pour l'école proche de ce domaine. Sa géométrie et ses fenêtres laissent pénétrer avec dynamisme la lumière qui inonde l'espace et renvoie la tranquillité nécessaire à son usage et à la méditation.

Además de ser una capilla, este proyecto cuenta con una biblioteca y aulas para la escuela que se encuentra a un costado de este predio. La geometría y sus ventanales permiten el acceso de luz de manera dinámica, prevaleciendo en el espacio y devolviendo la tranquilidad necesaria para su uso y meditación.

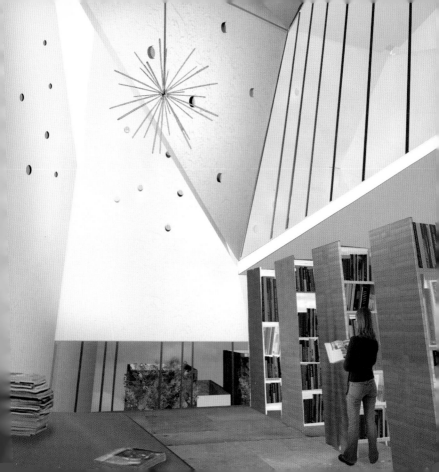

ITESM Campus Santa Fe
University Campus

Legorreta + Legorreta
Correa Hermanos (SE)

2001
Av. Carlos Lazo 100
Santa Fe

www.legorretalegorreta.com

The distribution scheme for the five buildings that are part of this monumental project is conceived in the most open possible way to provide views to the valleys of the city. Inspired by the old colonial cloisters, each of the buildings has a central patio that serves as a meeting point.

Das Gliederungsschema der fünf Gebäude dieses monumentalen Projekts ist so offen wie möglich konzipiert, um einen Ausblick auf die Täler der Stadt zu bieten. Jedes einzelne dieser Gebäude, inspiriert von den alten kolonialen Kreuzgängen, verfügt über einen zentralen Innenhof, der als Treffpunkt dient.

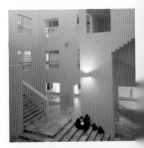

Le schéma de distribution des cinq édifices de ce projet monumental est conçu de la forme la plus ouverte possible afin de proportionner les vues sur les vallées de la ville. Inspiré des vieux cloîtres coloniaux, chacun des édifices dispose d'un patio central qui sert de lieu de rencontre.

El esquema de distribución de los cinco edificios de este proyecto monumental está concebido de la forma más abierta posible para proporcionar vistas hacia los valles de la ciudad. Inspirado en los viejos claustros coloniales, cada uno de los edificios cuenta con un patio central que sirve como un lugar de encuentro.

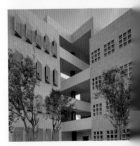

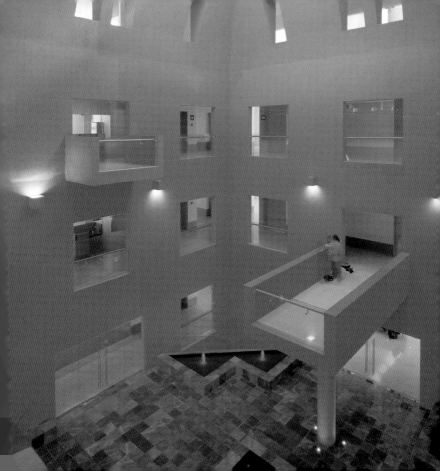

EBC Campus Tlalnepantla
Banking & Commercial School

Sánchez Arquitectos y Asociados
Izquierdo Ingenieros y Asociados (SE)

2005
Calle Cerro de las Campanas 98
San Andrés Atenco, Tlalnepantla

www.ebc.mx
www.sanchezarquitectos.com

The design of this educational building, located in a neighborhood with many students, was focused on establishing meeting points. A covered patio with a six-story high window faces the street, making a connection with all those who pass by.

Beim Entwurf dieses Lehrgebäudes, das sich in einem Viertel mit vielen Studierenden befindet, stand die Schaffung von Treffpunkten im Vordergrund. Ein überdachter Hof mit einem sechs Stockwerke hohen Fenster orientiert sich zur Straße hin und stellt eine Verbindung zu den Geschehnissen dort her.

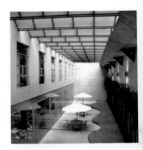

La conception de cet édifice éducatif situé dans un quartier fréquenté par beaucoup d'étudiants cherche à créer des lieux de rencontre. Un patio couvert, caractérisé par une baie vitrée sur six niveaux, donne sur la rue, entrant en contact avec tout se qui se passe par-là.

El diseño de este edificio educativo ubicado en un barrio con muchos estudiantes se enfocó en generar lugares de encuentros. Un patio cubierto, con un ventanal de seis niveles se orientó hacia a la calle contactándose con todo aquel que pasa por ahí.

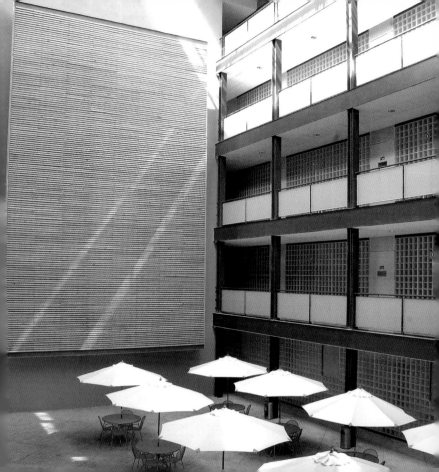

Conjunto Juárez
(Plaza Juárez, Secretaría de Relaciones Exteriores – Torre
Tlatelolco, Tribunal Superior de Justicia del Distrito Federal)
Juárez Complex Master Plan & Plaza Juárez

Legorreta + Legorreta

2005
Av. Juárez
Centro Histórico

www.legorretalegorreta.com

The objective behind this project was to regenerate the historic center of the city that was severely damaged by the 1985 earthquake. The new headquarters for the Foreign Affairs Ministry and the Superior Court of Justice of the Federal District, as well as the mixed-use buildings, open spaces, passages and plazas are part of this complex.

Dieses Projekt hat das Ziel, das bei den Erdbeben von 1985 schwer beschädigte historische Zentrum der Stadt wiederaufzubauen. Der neue Sitz des Außenministeriums und das Oberlandesgericht des Bundesstaats sowie Gebäude für unterschiedliche Zwecke sind Teil dieses Komplexes, zu dem auch offene Flächen, Fußgängerzonen und Plätze zählen.

Cet ensemble vise à restaurer le centre historique de la ville qui fut sérieusement endommagé par les séismes de 1985. Le nouveau siège du ministère des Affaires Etrangères et de la Haute Cour de la DF font ainsi partie, comme édifices d'usage mixte, de cet ensemble composé d'espaces ouverts, de rues piétonnes et de places.

Este proyecto tiene como objetivo regenerar el Centro Histórico de la ciudad que fue severamente dañado por los sismos de 1985. La nueva sede de la Secretaria de Relaciones Exteriores y el Tribunal Superior de Justicia del D.F. así como edificios de uso mixto, espacios abiertos, andadores y plazas forman parte de este conjunto.

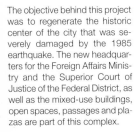

104

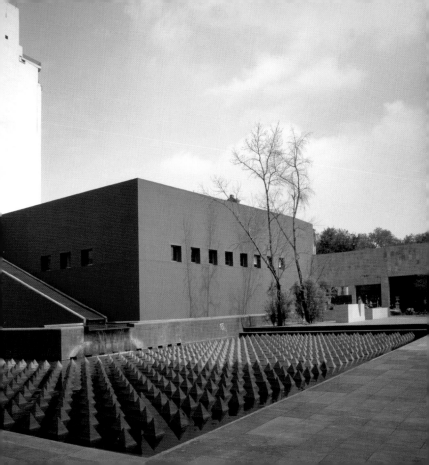

Reforma 222
Mixed-Use Complex

LAR / Fernando Romero
Izquierdo Ingenieros y Asociados (SE)

2007
Paseo de la Reforma / Insurgentes
Lomas de Chapultepec

www.laboratoryofarchitecture.com

A site defined by two of the most important avenues, Reforma and Insurgentes, was seeking for a multi-programmatic building proposal to house living spaces, a hotel, offices and a shopping center. The concept originated from a diagram in which a series of sections defined the shape of the building.

Ein Standort, der durch zwei der wichtigsten Alleen definiert wird: Reforma und Insurgentes. Es wurde ein Vorschlag für ein multifunktionales Gebäude gesucht, das Wohnungen, ein Hotel, Büros und ein Einkaufszentrum beherbergt. Das Konzept hatte seinen Ursprung in einem Diagramm, in dem eine Reihe von Einschnitten dem Gebäude seine Form gab.

Un emplacement défini par deux des avenues les plus importantes: Reforma et Insurgentes. La recherche s'est dirigée vers un projet de construction multi-activités abritant des logements, un hôtel, des bureaux et un centre commercial. L'idée est partie d'un diagramme où une série d'entailles a donné forme à la construction.

Un emplazamiento definido por dos de las avenidas más importantes, Reforma e Insurgentes, buscaba una propuesta de un edificio multi-programático que albergará viviendas, un hotel, oficinas y un centro comercial. El concepto se originó de un diagrama en donde una serie de cortes le dio forma al edificio.

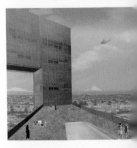

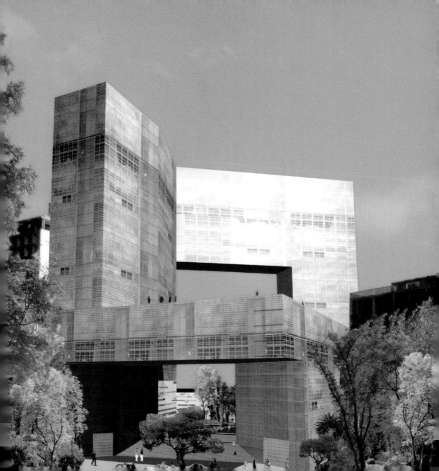

Bosque de Chapultepec
Rehabilitación de la Primera Sección
Chapultepec Forest Rehabilitation of the First Section

Grupo de Diseño Urbano, Mario Schjetnan
Enrique Clever Medrano (SE)

2006
Paseo de la Reforma /
Av. Constituyentes
Chapultepec

www.gdu.com.mx

The integral rehabilitation was realized from an extended Master Plan that includes: infrastructure, lakes, and environmental rehabilitation of the forest, services, concessions, urban furniture, signs and new specific projects. Especially, points of access, "mirror path" between museums, botanical garden and Calzada del Rey.

Die einheitliche Erneuerung wurde durch einen breit angelegten Master Plan realisiert, der Infrastruktur, Seen, Wiederaufforstung, Serviceeinrichtungen, Genehmigungen, städtisches Mobiliar, Beschilderung und einige neue Projekte umfasst. Besonders hervorzuheben sind die Zugänge sowie ein „Spiegelpfad" zwischen den Museen, dem botanischen Garten und Calzada del Rey.

La réhabilitation intégrale a été réalisée à partir d'un plan maître extensif, qui comprend l'infrastructure, les lacs et la réhabilitation environnementale de la forêt, les services, les concessions, le mobilier urbain, les panneaux et des nouveaux projets spécifiques. Notamment les points d'accès, le « sentier aux miroirs » entre les musées, le jardin botanique et la Calzada del Rey.

La rehabilitación integral se realizó a partir de un amplio Plan Maestro que incluye: infraestructura, lagos, rehabilitación ambiental del bosque, servicios, concesiones, mobiliario urbano, señalización y proyectos puntuales nuevos. En especial; accesos, "paseo-espejo" entre museos, jardín botánico y Calzada del Rey.

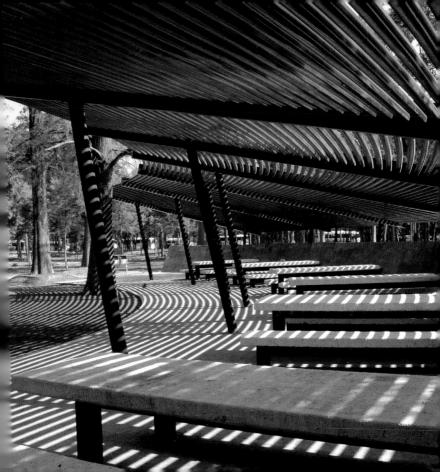

TecnoParque Azcapotzalco
High-Tech Office Campus

G + A arquitectos, Humberto Gloria / Alberto Askenazi
Grupo de Diseño Urbano, Mario Schjetnan / José Luís Pérez
Carlos Alfredo Tapia, CTC Ingenieros Civiles (SE)

2005
Av. de las Granjas 972 / Eje 5 Norte
Santa Bárbara, Azcapotzalco

www.tecnoparque.com
www.gdu.com.mx

Designed under the most rigid of international standards, on a surface area of 1,600,000 sqft and a campus concept, spectacular open plazas and green areas promote a pleasant and productive work environment. In this project a special emphasis was placed on the management, re-use and recycling of water.

Bei diesem Entwurf nach dem Vorbild eines Campus, gemäß strikter internationaler Standards auf einer Fläche von 142.000 m² entstanden, fördern spektakuläre offene Plätze und Grünflächen ein angenehmes und produktives Klima. Bei diesem Projekt wurde speziell auf die Nutzung, Wiederverwendung und Wiederaufbereitung von Wasser geachtet.

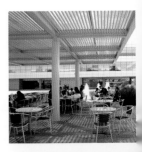

Conçu conformément aux normes internationales les plus rigoureuses, sur une superficie de 142.000 m² et selon un concept de campus avec des places ouvertes spectaculaires et des zones de verdure qui suscitent une ambiance de travail agréable et productive, ce projet souligne tout particulièrement la gestion, la réutilisation et le recyclage de l'eau.

Diseñado bajo los más rigurosos estándares internacionales, sobre una superficie de terreno de 142,000 m² y un concepto de campus, espectaculares plazas abiertas y áreas verdes fomentan un ambiente de trabajo agradable y productivo. En este proyecto se dedicó un énfasis especial en el manejo, re-uso y reciclaje de agua.

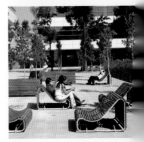

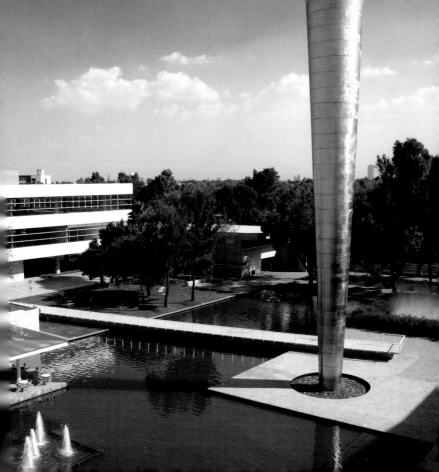

Ampliación de la Terminal 1 del
Aeropuerto Internacional
de la Ciudad de México y Construcción de la Nueva Terminal 2
Terminal 1 Extension of Mexico City International Airport &
Construction of the New Terminal 2

Serrano Arquitectos y Asociados S.C.

2006
Av. Capitán Carlos León S/N
Peñón de los Baños

www.asa.gob.mx
www.aicm.com.mx

In order to meet the growing demand of air traffic, a new Terminal 2 and the expansion and modernization of the Terminal 1 was planned. The project includes the construction of two distribution routes including an internal linear route of approximately 5 miles and an air train, transporting 6,800 passengers a day.

Mit dem Ziel, die erhöhte Nachfrage im Luftverkehr abzudecken, wurden ein neues Terminal 2 und die Erweiterung und Modernisierung des Terminals 1 geplant. Zum Projekt gehören zwei Verkehrsverteiler, ein internes Wegesystem mit einer Länge von rund 8,5 km sowie Schienenfahrzeuge, die täglich 6.800 Passagiere transportieren.

Afin de répondre à la demande croissante du trafic aérien, on prévoit la création du nouveau Terminal 2, ainsi que l'agrandissement et la modernisation du Terminal 1. Le projet comprend la construction de deux réseaux routiers inclus la viabilité interne en une extension d'environ 8,5 km de lignes et un air train, transportant 6.800 passagers par jour.

Con el fin de cubrir la creciente demanda del tráfico aéreo se proyectó una nueva Terminal 2 y la ampliación y modernización de la Terminal 1. El proyecto incluye la construcción de dos distribuidores viales incluyendo una vialidad interna en una extensión aproximada de 8.5 kilómetros lineales y un tren aéreo, transportando 6,800 pasajeros diarios.

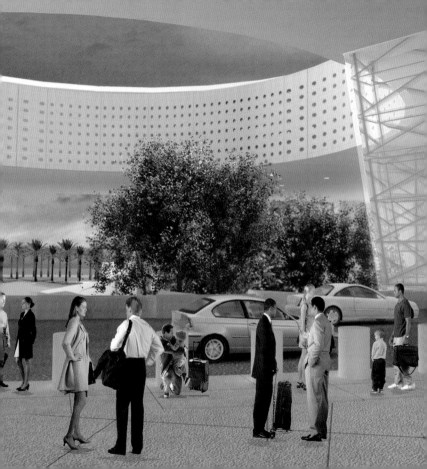

to stay . hotels

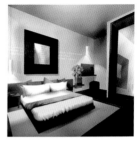
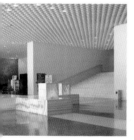
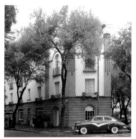
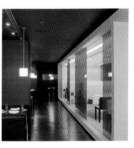
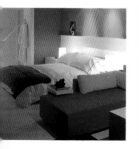
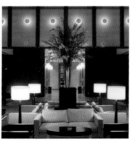
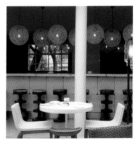

CONDESA df

Higuera + Sánchez
India Mahdavi, imh interiors
Colinas de Buen, S.A. de C.V. (SE)

2005
Av. Veracruz 102
Condesa

www.condesadf.com
www.higuera-sanchez.com

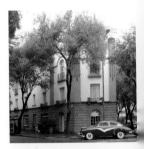

The perimeter of this building, originating from 1928, has been kept as the exterior image of the hotel. The spaces are created from a courtyard that penetrates the building right at the center, provoking the link between all public spaces up to the roof-top.

Die äußeren Konturen dieses Gebäudes von 1928 wurden als Aushängeschild des Hotels beibehalten. Die Räume verteilen sich um einen Innenhof im Zentrum. Dieser verbindet alle Räume bis hin zur Dachterrasse.

Le périmètre de l'édifice, datant de 1928, constitue l'image de l'hôtel à l'extérieur. Les espaces sont créés à partir d'une cour vide intérieure qui pénètre le projet en plein centre, provoquant la communication entre tous les espaces publics jusqu'à la toiture-terrasse.

El perímetro del edificio, de 1928, se mantiene como la imagen del hotel al exterior. Los espacios son generados a partir de un patio vació interior que penetra al proyecto justo en el centro, provocando la comunicación entre todos los espacios públicos hasta la azotea.

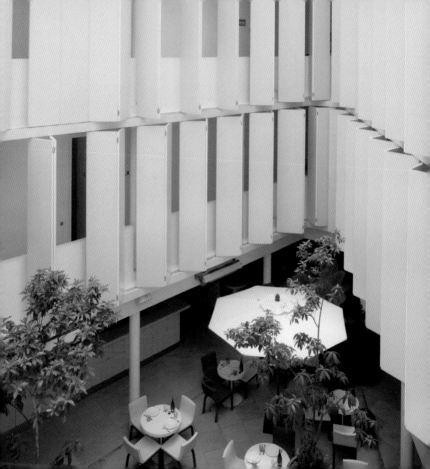

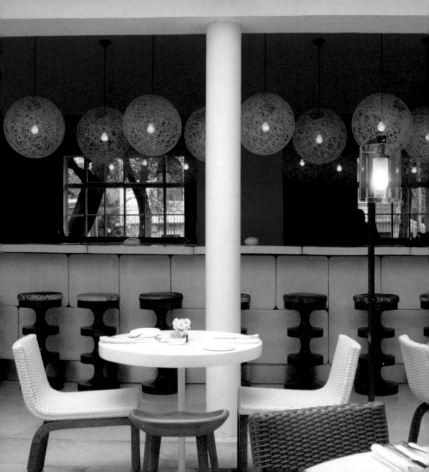

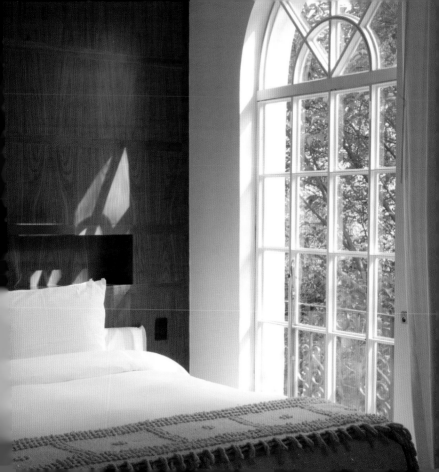

Hippodrome

Atelier N.D.K. Architecture, Nahim Dagdug Kalife

2006
Av. México 188
Condesa

www.stashhotels.com

A revitalized art deco building from the 1930s now houses a contemporary hotel with 15 guest rooms and a suite. The original language of the building was respected, preserving the façade in its entirety and restoring it with the authorization of the Instituto Nacional de Bellas Artes.

Dieses renovierte Art-déco-Gebäude der 30er Jahre beherbergt ein modernes Hotel mit 15 Zimmern und einer Suite. Im Zuge der Modernisierung wurde der Originalstil bewahrt, die Fassade in ihrer Gesamtheit erhalten und die Restaurierung mit Genehmigung des Instituto Nacional de Bellas Artes durchgeführt.

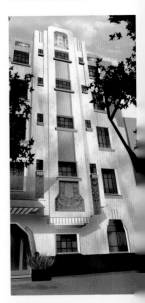

Un édifice art déco des années 1930 racheté abrite un hôtel contemporain comprenant 15 chambres et une suite. Sa rénovation respecte le langage d'origine, conservant l'intégralité de la façade et la restaurant avec l'autorisation de l'Instituto Nacional de Bellas Artes (Institut national des beaux-arts).

Un edificio rescatado art déco de los años 30 aloja un hotel contemporáneo con 15 habitaciones y una suite. En su remodelación se respetó el lenguaje original, conservando la fachada en su totalidad y restaurándola con la autorización del Instituto Nacional de Bellas Artes.

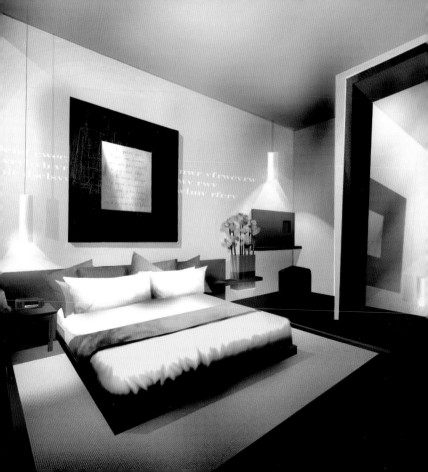

Sheraton Centro Histórico

Pascal Arquitectos

2002
Av. Juárez 70
Centro Histórico

www.sheratonmexico.com
www.pascalarquitectos.com

The modern and provocative design of this 27-story hotel includes state-of-the-art technology and intentionally breaks from the norm. Creating at the same time the recovery of real-estate of the area means acquiring a new potential.

Das moderne und provokative Design dieses Hotels, das über 27 Stockwerke verfügt, integriert die modernsten Technologien und fällt absichtlich aus dem Rahmen. Es wertet gleichzeitig die umliegenden Immobilien auf, die so ein neues Potential erhalten.

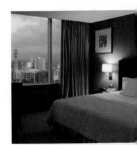

La conception moderne et provocatrice de cet hôtel de 27 étages intègre les dernières technologies et rompt intentionnellement avec le contexte, créant de la même façon la récupération immobilière de la région qui aquiert un nouveau potentiel.

El diseño moderno y provocativo de este hotel que cuenta con 27 pisos integra las últimas tecnologías y rompe intencionalmente con el contexto. Generando de igual forma la recuperación inmobiliaria de la zona que adquiere un nuevo potencial.

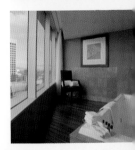

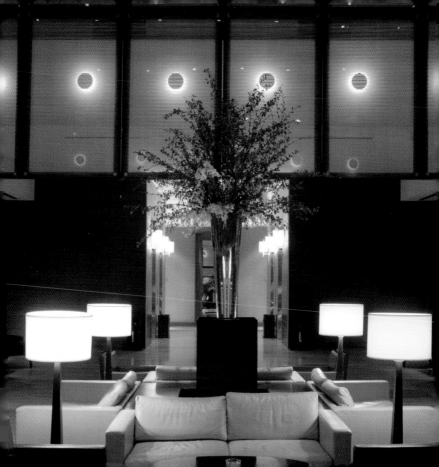

Hotel Mumedi y Mumedishop

Álvaro Rego García de Alba

2005, 2007
Francisco I. Madero 74
Centro Histórico

www.mumedi.org

This house was built on top of the palace of the Spanish conqueror Hernán Cortés. Its foundations are part of the pyramid of the Aztec Emperor Huehue Moctezuma Ilhuicamina and it now houses the Mexican Design Museum, as well as five exclusive contemporary rooms distributed within its installations.

Dieses Haus wurde über dem Palast des spanischen Eroberers Hernán Cortés errichtet, seine Fundamente sind Teil der Pyramide des aztekischen Herrschers Huehue Moctezuma Ilhuicamina. Es beherbergt jetzt das mexikanische Museum für Design, das über fünf exklusive, moderne Zimmer verfügt, die in der Anlage verteilt sind.

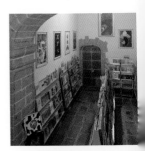

Cette maison fut construite sur le palais de Hernán Cortés, le conquistador espagnol, ses fondations sont une partie de la pyramide de l'Empereur aztèque Huehue Moctezuma Ilhuicamina et elle abrite maintenant le Musée Mexicain de Design qui comporte cinq salles contemporaines exclusives, distribuées à l'intérieur des installations.

Esta casa fue construida sobre el palacio del conquistador español Hernán Cortés, sus cimientos son parte de la pirámide del Emperador Azteca Huehue Moctezuma Ilhuicamina y ahora aloja al Museo Mexicano de Diseño que cuenta con cinco exclusivas habitaciones contemporáneas distribuidas dentro de sus instalaciones.

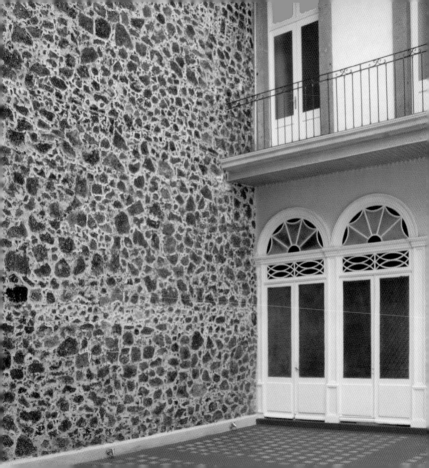

Camino Real México

Legorreta Arquitectos
Bernardo y José Luis Calderón (SE)

1968, 2005
Mariano Escobedo 700
Anzures

www.caminoreal.com
www.legorretalegorreta.com

Elegance and the architectural style of a hotel-museum come together in this hotel, sheltering the hectic life of the city amongst gardens, swimming pools, fountains and patios. Despite its many rooms and suites—the use of vibrant colors and the penetrating light reduces its magnitude.

In diesem Hotel vereinen sich Eleganz und architektonischer Stil zu einem Hotel-Museum, in dem man vor dem hektischen Leben der Stadt zwischen Gärten, Schwimmbädern, Quellen und Innenhöfen Zuflucht findet. Trotz der vielen Zimmer und Suiten relativiert sich die Größe durch die vibrierenden Farben und das in die Räume einfallende Licht.

C'est sur cet hôtel que s'appuient l'élégance et le style architectural d'un hôtel-musée, réfugiant la vie agitée de la ville dans des jardins, des piscines, des fontaines et des cours. Malgré son grand nombre de chambres et de suites, la dimension est diluée par les couleurs vibrantes et la lumière s'infiltrant dans les espaces.

En este hotel se funde la elegancia y estilo arquitectónico de un hotel-museo, refugiando la vida agitada de la ciudad entre jardines, piscinas, fuentes y patios. A pesar de su gran cantidad de habitaciones y suites la dimensión se diluye con los colores vibrantes y luz que penetra los espacios.

126

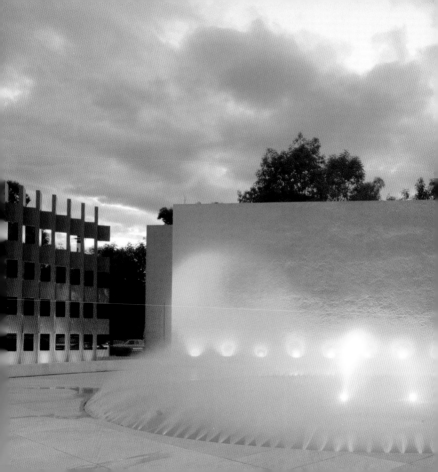

to stay . hotels: 53

W Mexico City

Studio GAIA / Ilan Waisbrod

2003
Campos Eliseos 252
Polanco

www.starwoodhotels.com
www.studiogaia.com

This is the first W hotel in Latin America, different to all other W hotels because of its passionate and youthful style. The use of native Mexican materials, Koi ponds in the interior, a terrace with fireplaces and vibrant colors give it a relaxing and seductive ambience.

Dies ist das erste W-Hotel in Lateinamerika und unterscheidet sich von allen anderen Ws durch seinen temperamentvollen und jugendlichen Stil. Die Nutzung einheimischer mexikanischer Materialien, Koi-Teiche im Inneren, eine Terrasse mit Kaminen und lebendige Farben schaffen ein entspannendes und verführerisches Ambiente.

Il s'agit du premier hôtel W en Amérique latine, qui se distingue de tous les autres par son style ardent et jeune. L'emploi de matériaux indigènes mexicains, les bassins de carpes koï à l'intérieur, la terrasse garnie de cheminées et les couleurs vives créent une ambiance décontractante et séduisante.

Este es el primer W hotel en Latinoamérica, diferente a todos los W por su estilo ardiente y juvenil. El uso de materiales indígenas mexicanos, estanques de koi en el interior, una terraza con chimeneas y colores vivos crean un ambiente relajante y seductor.

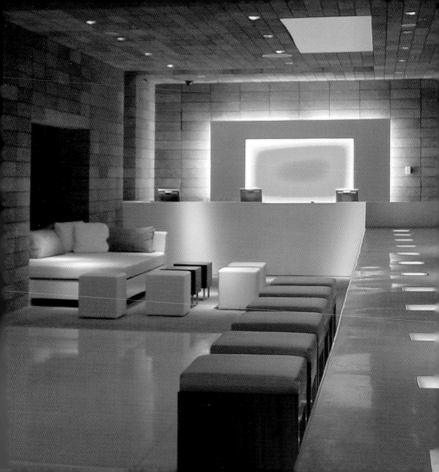

Habita Hotel

TEN Arquitectos/Enrique Norten

2000
Av. Presidente Masaryk 201
Polanco

www.hotelhabita.com
www.ten-arquitectos.com

An apartment building from the 1950s was converted into a 36-room lifestyle hotel, gaining a new identity. The lightness and transparency of the envelope, suspended from the original façade, are enunciated with a frosted glass, wrapping the hotel in a glass box.

Ein Apartmentkomplex aus den 50er Jahren hat eine neue Identität erhalten und wird zu einem Lifestylehotel mit 36 Zimmern. Das matte Glas der Verkleidung, durch das das Hotel in einen Glaskasten eingeschlossen wird, der an der Originalfassade angebracht ist, drückt Leichtigkeit und Transparenz aus.

Un complexe d'appartements des années 1950 a pris une nouvelle identité, se transformant en un hôtel-boutique de 36 logements. La légèreté et la transparence de l'enveloppe sont accentuées par un verre poli à l'émeri enfermant l'hôtel dans une caisse de verre suspendue à la façade d'origine.

Un complejo de departamentos de los años 50 ha cobrado nueva identidad, transformándose en un lifestyle hotel de 36 habitaciones. La ligereza y transparencia de la envolvente se acentúan con un cristal esmerilado, encapsulando el hotel en una caja de cristal suspendido de la fachada original.

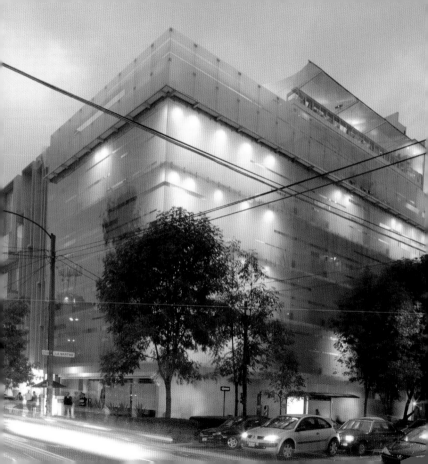

Hoteles Fiesta Inn
y Fiesta Americana Santa Fe

Picciotto Arquitectos

2006
Calle 3, 55
Santa Fe

www.fiestainn.com
www.picciotto.com

This sculptural hotel is located in Santa Fe — the new financial and corporate district of the Mexican capital. Its 351 luxury rooms, including business facilities and suites, offer spectacular views of the Valley of Mexico.

Dieses herrlich gestaltete Hotel befindet sich in Santa Fe, dem neuen Finanz- und Geschäftsviertel der mexikanischen Hauptstadt. Seine 351 Luxuszimmer, einschließlich Executive-Etagen und Suiten, bieten einen eindrucksvollen Blick auf das Tal von Mexiko.

Cet hôtel sculptural est situé à Santa Fe, le nouveau quartier financier et commercial de la capitale mexicaine. Ses 351 chambres de luxes, y compris les pièces d'affaires et les suites, offrent des vues spectaculaires sur la vallée de Mexico.

Este hotel escultural está ubicado en Santa Fe, el nuevo distrito financiero y corporativo de la capital mexicana. Sus 351 habitaciones de lujo, incluyendo pisos ejecutivos y suites, ofrecen vistas espectaculares al Valle de México.

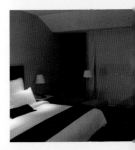

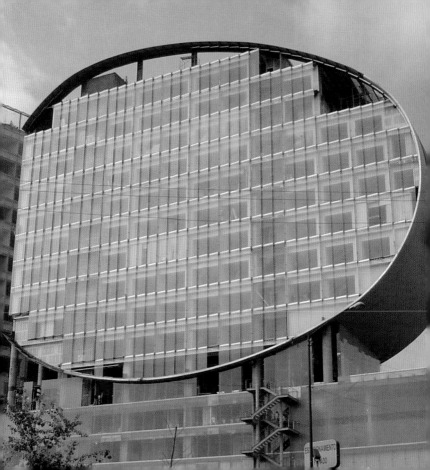

to go . eating
 drinking
 clubbing
 wellness, beauty & sport

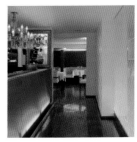
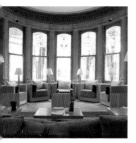
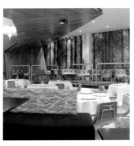
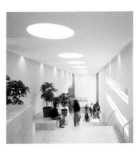
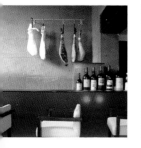
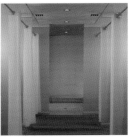
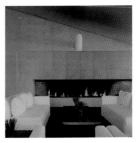

Restaurante Lamm

Serrano Monjaraz Arquitectos

2005
Av. Álvaro Obregón 99
Roma

www.lamm.com.mx
www.serranomonjaraz.com

Located in the *Centro de Cultura Casa Lamm*, this restaurant combines the porfirian architecture from the beginning of the 20th century with the transparency and post-modernistic elegance of the 21st century. Its glass façade in the main area opens half-way up, integrating natural ventilation and complete harmony with its surroundings.

Dieses Restaurant im *Centro de Cultura Casa Lamm* kombiniert die porfirianische Architektur vom Anfang des 20. Jahrhunderts mit der postmodernen Transparenz und Eleganz des 21. Jahrhunderts. Seine Glasfassade im Hauptbereich öffnet sich auf halber Höhe und gewährleistet so eine natürliche Belüftung und völlige Einbindung in die Umgebung.

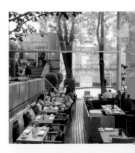

Situé dans le *Centro Cultural Casa Lamm*, ce restaurant combine l'architecture « porfiriana » du début du 20ème siècle avec la transparence et l'élégance post-modernistes du 21ème siècle. Sa façade de verre dans l'aire principale s'ouvre à mi-hauteur, intégrant la ventilation naturelle et une liaison totale avec ses environs.

Situado en el *Centro de Cultura Casa Lamm*, este restaurante combina la arquitectura porfiriana de principios del siglo XX con la transparencia y elegancia post-modernista del siglo XXI. Su fachada de vidrio en el área principal se abre a media altura integrando ventilación natural y una conexión total con sus alrededores.

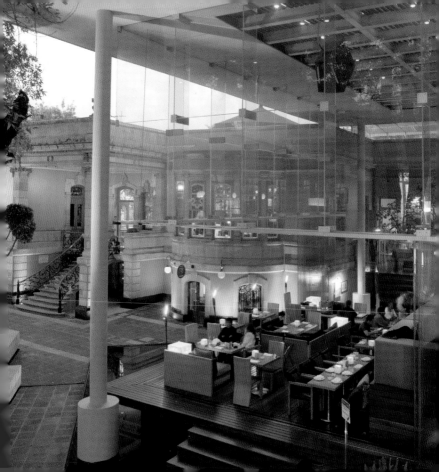

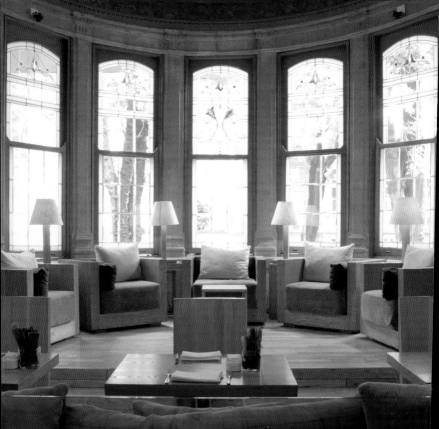

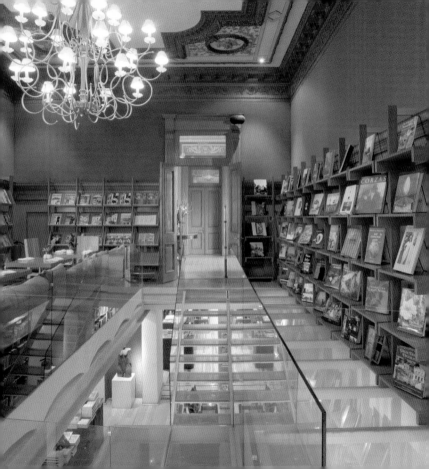

Blue Lounge
(Camino Real México)

Legorreta + Legorreta

2000
Mariano Escobedo 700
Anzures

www.legorretalegorreta.com

Meet the first over-water bar. Located within the Hotel Camino Real de México, this minimalist bar combines the main elements of Mexican architecture: blue walls, the use of water, color and light that filters into the interior and gives the illusion of floating in space.

Lernen Sie die erste Bar auf dem Wasser kennen! Diese minimalistische Bar befindet sich im Hotel Camino Real de México und kombiniert die Hauptelemente der mexikanischen Architektur miteinander: blaue Mauern, die Nutzung von Wasser, Farbe und Licht, das in den Innenbereich strömt und somit die Illusion hervorruft, im Raum zu schweben.

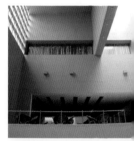

Découvrez le premier bar sous l'eau. Situé dans l'Hotel Camino Real de Mexico, ce bar minimaliste combine les éléments principaux de l'architecture mexicaine : murs bleus, usage de l'eau, couleur et lumière s'infiltrant à l'intérieur en donnant l'illusion de flotter dans l'espace.

Conozca el primer bar sobre el agua. Situado dentro del Hotel Camino Real de México, este bar minimalista combina los elementos principales de la arquitectura mexicana: muros azules, el uso de agua, color y luz que se filtra en el interior dando la ilusión de estar flotando en el espacio.

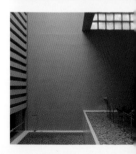

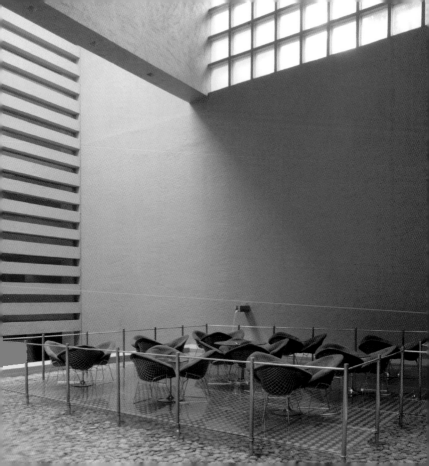

Ivoire

Francisco Hanhausen Arquitectura y Diseño

2005
Emilio Castelar 95
Polanco

www.hanhausen.com

This cozy and contemporary location invites you to go to the countryside in the middle of a metropolis, with a gourmet store and wine cellar visible through the store floor, a glass-roofed terrace and garden. Its cheerful and decadent ambience is unique in Polanco.

Dieser gastfreundliche und moderne Ort lädt Sie ein, mitten in einer Metropole „aufs Land zu fahren". Dort gibt es ein Delikatessengeschäft, durch dessen Fußboden ein Weinkeller sichtbar ist, und eine mit Glas überdachte Terrasse mit Garten. Die fröhliche und dekadente Atmosphäre ist in Polanco einmalig.

Ce lieu accueillant et contemporain est une invitation à la campagne en plein cœur d'une métropole ; avec une boutique gourmet, une cave à visiter en passant par le sous-sol, une terrasse à toiture de verre et une jardinière. Son ambiance joyeuse et décadente est unique à Polanco.

Este lugar acogedor y contemporáneo te invita a ir al campo en medio de una metrópolis; con una tienda gourmet, cava visible a través del piso, una terraza techada con vidrio y jardinera. Su *ambience* feliz y decadente es único en Polanco.

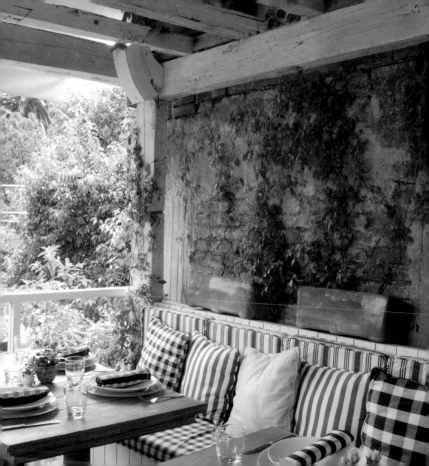

D.O. denominación de origen

Higuera + Sánchez

2002
Heguel 406
Polanco

www.higuera-sanchez.com

This place with Spanish character used to be an Italian restaurant. The exterior dimension of the façade was respected, adding only black vinyl to change the image of the glass surface and to make it more attractive to the passers-by and more private for the guests in the dining area.

Dieser Ort mit spanischem Charakter war einmal ein italienisches Restaurant. Die Fassadengestaltung wurde beibehalten und es wurde schwarzes Vinyl angebracht, um das Aussehen der Fenster zu verändern: Das Gebäude sollte so bei Wahrung der Privatsphäre der Gäste für die Passanten attraktiver gemacht werden.

Ce lieu de caractère espagnol était un restaurant italien. La volumétrie extérieure en façade se respecte, n'ayant recours qu'à des vinyles noirs pour changer l'image des vitres et la rendant plus attirante pour le passant, mais plus privée pour le convive.

Esta índole española solía ser un restaurante italiano. La volumétria exterior en la fachada se respetó, adhiriendo solo viniles negros para cambiar la imagen de los cristales y hacerla más atractiva al transeúnte pero más privada al comensal.

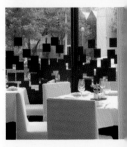

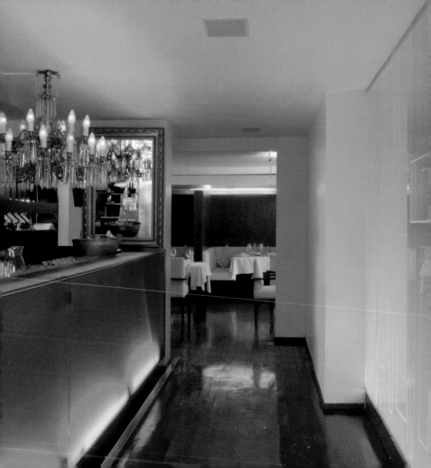

Área Bar and Terrace
(Habita Hotel)

TEN Arquitectos/Enrique Norten

2000
Av. Presidente Masaryk 201
Polanco

www.hotelhabita.com
www.ten-arquitectos.com

This bar is located in the premises of Habita Hotel on the sixth floor, highlighted by a 12 ft-long outdoor fireplace and its relaxed atmosphere, fresh and minimal in style, it opens onto a spectacular panorama of the city.

Diese Bar befindet sich im sechsten Stock des Habita Hotels und sticht besonders durch ihren draußen liegenden, 4 m langen Kamin hervor. Der Stil ist entspannt, frisch, minimalistisch, und die Bar öffnet sich einem eindrucksvollen Panorama der Stadt.

Ce bar situé au sixième étage des installations de l'Habita Hotel se distingue par sa cheminée extérieure de 4 m de large. De style relaxant, frais et minimal, il offre un panorama spectaculaire de la ville.

Este bar está ubicado en el sexto piso de las instalaciones del Habita Hotel, se destaca por su chimenea exterior de 4 m de largo y su ambiente relajado, fresco, mínimo, abriéndose hacia un panorama espectacular de la ciudad.

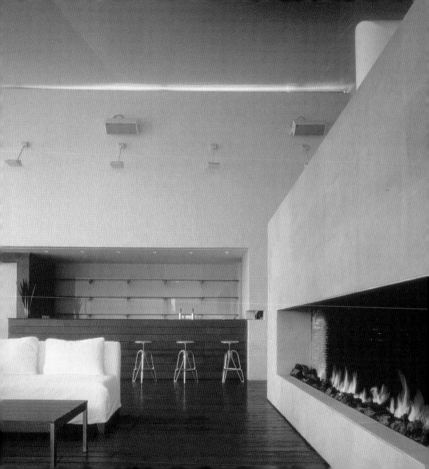

Boska Bar

Rojkind Arquitectos + Esrawe Diseño (Michel Rojkind with Hector Esrawe)
MONCAD / Jorge Cadena (SE)

2004
Plaza Escenaria, Av. San Jerónimo 263
San Ángel

www.rojkindarquitectos.com
www.esrawe.com

This bar remained in the hands of the original owner and architects to become a new space. Its elongated entrance, similar to that of a tunnel, was resolved with a wooden deck that folds and unfolds to become a roof, wall and platform defining the length and fluidity of the interior.

Diese Bar, die in den Händen des gleichen Eigentümers und der ursprünglichen Architekten verblieb, sollte in einen neuen Raum umgewandelt werden. Ihr tunnelartiger Eingang wurde mit einer Holzabdeckung versehen, die sich zusammen- oder auseinandergefaltet in Decke, Wand oder Bühne verwandelt und die Länge und den fließenden Charakter des Innenraums definiert.

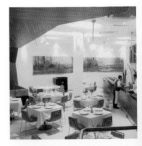

Ce bar reste dans les mains du même propriétaire et des architectes pour se transformer en un nouvel espace. Sa grande entrée semblable à celle d'un tunnel se transforme en une couverture de bois qui se double et se dédouble pour se convertir en toit, paroi et plateforme définissant la longitude et la fluidité de l'intérieur.

Este bar se quedo en manos del mismo propietario y arquitectos para crear un nuevo espacio. Su larga entrada similar a la de un túnel se resolvió con una cubierta de madera que se dobla y desdobla para convertirse en techo, pared y plataforma definiendo la longitud y fluidez del interior.

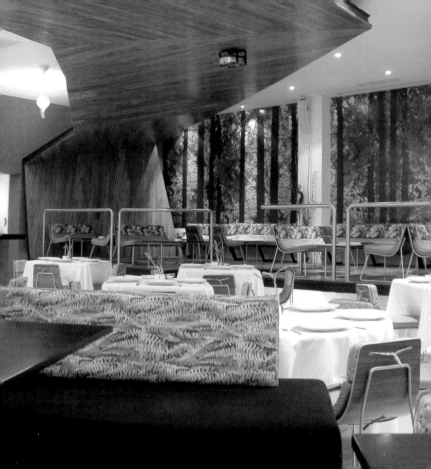

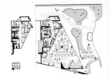

Restaurante Guria Santa Fe

Pascal Arquitectos

2005
Torre Acuario, Av. Javier Barros
Sierra 55
Santa Fe

www.pascalarquitectos.com

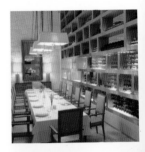

This project was developed from a contemporary interpretation of large Basque houses. The starting point of the spatial distribution scheme was a 20 ft-high lobby with irregular limestone walls to invigorate and give visual weight to the space.

Dieses Projekt ergibt sich aus der zeitgenössischen Interpretation der baskischen Landhäuser. Die Räumlichkeiten verteilen sich um eine Empfangshalle mit einer Höhe von 6 m und Wänden aus unregelmäßigem Kalkstein, der dem Raum Festigkeit und sichtbares Gewicht verleiht.

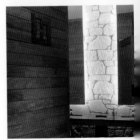

Cette œuvre vient de l'interprétation contemporaine des demeures vasques. Le schéma de répartition spatial a comme point de départ un hall de réception de 6 m de hauteur aux murs en chaux inégaux lui donnant sa solidité et un équilibre visuel de l'espace.

Esta obra surge de la interpretación contemporánea de las casonas vascas. El esquema de distribución espacial tiene como punto de partida un vestíbulo de recepción de 6 m de altura con muros de piedra de caliza irregular dándole solidez y peso visual al espacio.

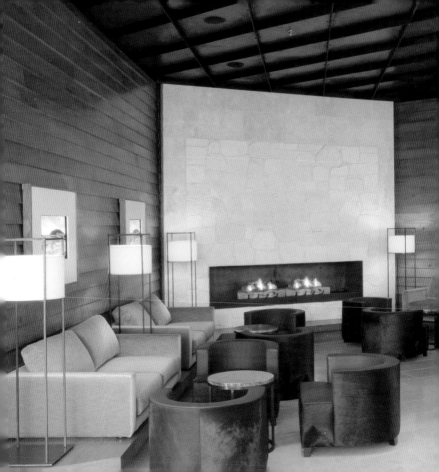

Centro QI
Fitness Center

Higuera + Sánchez

2001
Ámsterdam 317
Condesa

qi.com.mx
www.higuera-sanchez.com

The design of this award-winning gymnasium consisted in adding and removing elements to the existing structure, stripping it off arches and balconies. The rear patio was converted into a climbing wall and a new double skin that wraps the building changes from complete opacity by day to transparency at night.

Das Design dieses preisgekrönten Fitnessraums bestand darin, Elemente der bestehenden Struktur hinzuzufügen und wegzunehmen und sie so von Bögen und Balkons zu befreien. Der hintere Teil des Innenhofes verwandelte sich in eine Kletterwand, und die neue doppelte Umhüllung, die das Gebäude bedeckt, verändert sich von ihrer Lichtundurchlässigkeit am Tag bis hin zur Transparenz bei Nacht.

La conception de ce gymnase primé a consisté à ajouter et à soustraire des éléments à la structure existante, la dépouillant des arches et des balcons. Le patio postérieur s'est converti en un mur d'escalade, et la nouvelle superficie double que l'édifice a recouvrée change de toute évidence son imperméabilité jusqu'à la transparence de nuit.

El diseño de este gimnasio galardonado consistió en agregar y sustraer elementos a la estructura existente, desnudándola de arcos y balcones. El patio posterior se convirtió en un muro de escalar y la nueva superficie doble que recubre el edificio cambia desde su impermeabilidad hasta la transparencia de noche.

154

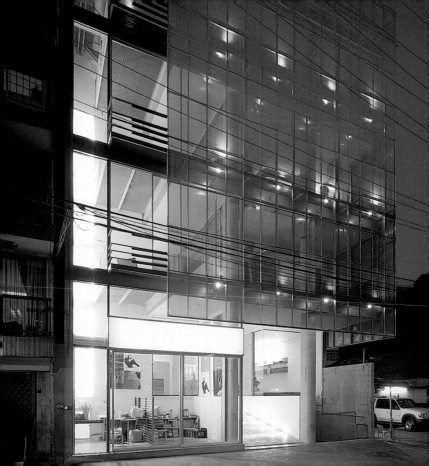

Sheraton Centro Histórico
Spa

Pascal Arquitectos

2006
Av. Juárez 70
Centro Histórico

www.sheratonmexico.com
www.pascalarquitectos.com

To extend the stay of the business traveler to the weekend, a spa, gymnasium and swimming pools were incorporated on the sixth floor of the Sheraton Centro Histórico Hotel, surrounded by a large 32,300 sqft garden with view to Alameda Central.

Um den Aufenthalt von Geschäftsreisenden über das Wochenende auszudehnen, wurden ein Wellness-Center, ein Fitnessraum und ein Schwimmbad im sechsten Stock des Hotels Sheraton Centro Histórico eingerichtet, die von einem 3000 m² großen Garten mit Blick auf die Alameda Central umgeben sind.

Pour prolonger le séjour des hommes d'affaires et les inciter à rester le week-end, un spa, un gymnase et des piscines ont été mis en œuvre au sixième étage de l'hôtel Sheraton Centro Histórico, dans un grand jardin de 3.000 m², avec vue sur Alameda Central.

Para extender la estadía del viajero de negocios al fin de semana, se integraron un spa, gimnasio y albercas de nado en el sexto piso del hotel Sheraton Centro Histórico, conformado por un gran jardín de 3,000 m², con vista a la Alameda Central.

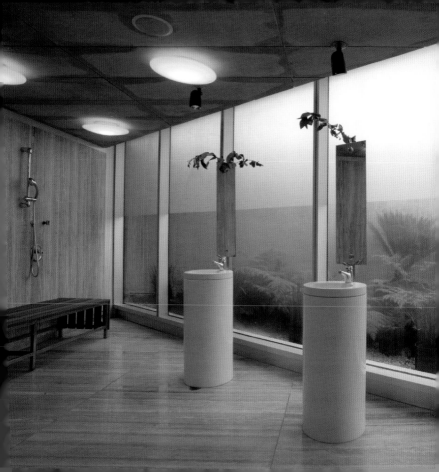

Salón de Usos Múltiples Tarbut
Multiple Use Building

Jaime Varon, Abraham Metta, Alex Metta / Migdal Arquitectos
CADAE Ingenieros – Carlos Álvarez (SE)

2005
Av. Loma del Parque 126
Lomas de Vista Hermosa

www.tarbut.edu.mx
www.migdal.com.mx

This educational project for children needed a multipurpose building for both sports, as well as cultural activities. A *box of colors* was created through a contemporary stained-glass window with stripes of vibrant colors that bathe the interior with trails of blended colors at different hours of the day and year.

Für dieses Bildungsprojekt für Kinder war ein Mehrzweckgebäude erforderlich, um sowohl sportliche als auch kulturelle Aktivitäten entwickeln zu können. Mittels eines modernen Kirchenfensters in farbenfrohen Streifen wurde ein *Farbkasten* entwickelt, der zu verschiedenen Tages- und Jahreszeiten das Innere mit strahlenförmigen Farbnuancen versieht.

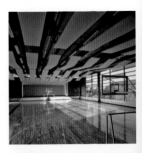

Ce projet éducatif pour enfants exigeait un édifice polyvalent pour mettre en avant des activités aussi bien sportives que culturelles. Une *caisse de couleurs* a été créée à partir d'un vitrail contemporain de franges de couleurs vives qui, à divers heures du jour et de l'année, baigne l'intérieur de traînées aux couleurs nuancées.

Este proyecto educativo para niños necesitaba de un edificio polivalente para desarrollar tanto actividades deportivas como culturales. Una *caja de colores* fue creada a través de un vitral contemporáneo de franjas de colores vivos que a diversas horas del día y del año baña el interior con estelas de matices de colores.

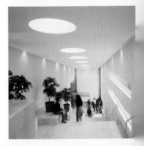

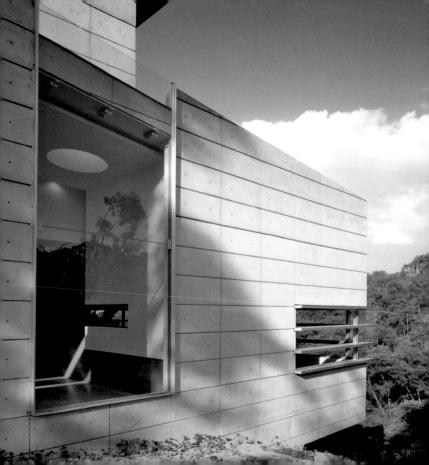

Centro Nacional de Rehabilitación
National Center of Rehabilitation

Sergio Mejía Ontiveros / Arquinteg, S.A. de C.V.

2004
Calzada México Xochimilco 289
Arenal de Guadalupe, Tlalpan

www.cnr.gob.mx
www.arquinteg.com.mx

This organic volume attempts to clearly create a special and humane ambience. Vibrant Mexican colors were applied in the interiors: yellow, orange, red, and Mexican pink bathing them with a natural light and changing their tones to make the atmosphere temporary and create a visual connection.

Dieser organische Raum beabsichtigt, eine besondere humane Atmosphäre zu erschaffen. Um ein zeitgemäßes Ambiente mit visuellem Bezug herzustellen, wurden die lebhaften mexikanischen Farben Gelb, Orange, Rot und Rosa verwendet, die im Tageslicht ihren Ton ändern.

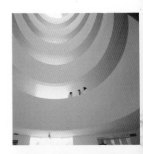

Cette volumétrie organique a pour intention précise de créer une ambiance spéciale et humaine. Pour temporaliser l'ambiance et créer une relation visuelle, on a choisi d'appliquer les couleurs vives de México dans les intérieurs, à savoir jaune, orange, rouge et rose mexicain, les baignant de lumière naturelle et changeant les teintes.

Esta volumetría orgánica tiene la intención precisa de crear un ambiente especial y humano. Para temporalizar el ambiente y crear una conexión visual, se eligió la aplicación de los colores vivos de México en los interiores: amarillo, naranja, rojo y rosa mexicano bañándolos con luz natural y cambiando las tonalidades.

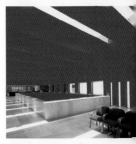

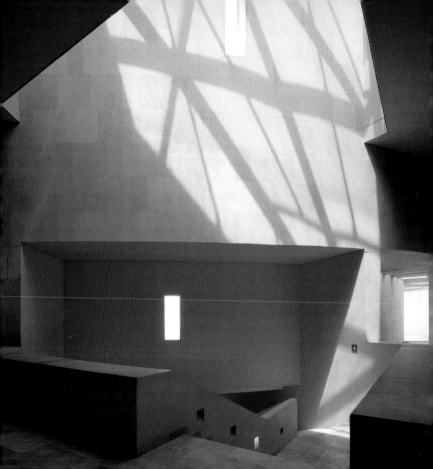

to shop . mall
 retail
 showrooms

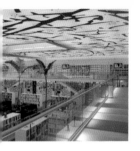

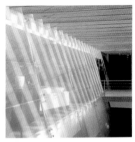
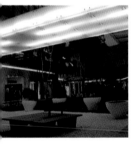
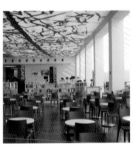
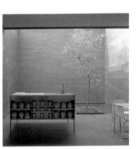
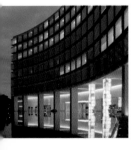
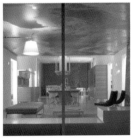
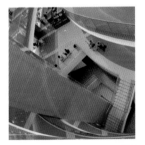

Centro Cultural Bella Época
Librería del Fondo de Cultura Económica Rosario Castellanos
Cultural Center & Bookstore

Teodoro González de León

2006
Tamaulipas 202 / Benjamín Hill
Condesa

www.fondodeculturaeconomica.com

The Cine Lido of the 1940s is now the biggest bookshop in Mexico with 250,000 books on display, a cinema and an art gallery. This large modern space filled with light is characterized by the work of Jan Hendrix, a panel with 256 sheets of glass that simulate a bamboo branches.

Das Lido-Kino aus den 40er Jahren ist jetzt die größte Buchhandlung Mexikos mit 250.000 Büchern, einem Kinosaal und einer Kunstgalerie. Dieser große, moderne und helle Raum wird durch das Werk von Jan Hendrix bestimmt, einer Decke mit 256 Glasplatten, die ein Bambusgeäst simulieren.

Le siège du cinéma Lido des années 1940 est aujourd'hui la plus grande bibliothèque de Mexico avec 250.000 livres en exposition, une salle cinématographique et une galerie d'arts. Ce vaste espace, moderne et très lumineux, se caractérise par l'œuvre de Jan Hendrix, un toit formé de 256 feuilles de verre qui imitent un branchage de bambou.

El cine Lido de los años 40 ahora es la librería más grande de México con 250,000 libros en exhibición, una sala cinematográfica y una galería de arte. Este espacio amplio, moderno y lleno de luz se caracteriza por la obra de Jan Hendrix, un plafón con 256 hojas de cristal que simulan un ramaje de bambú.

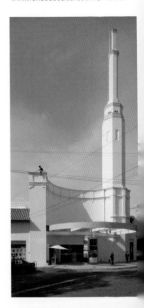

164

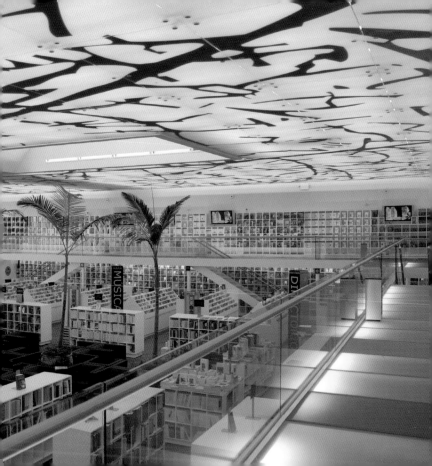

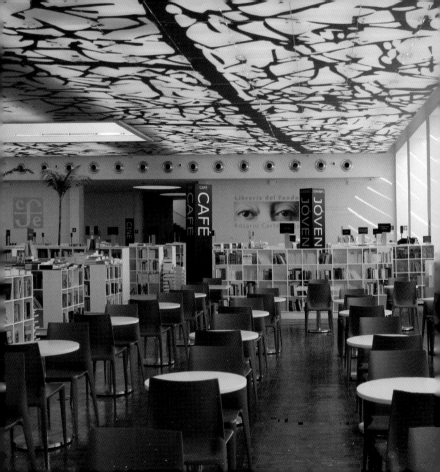

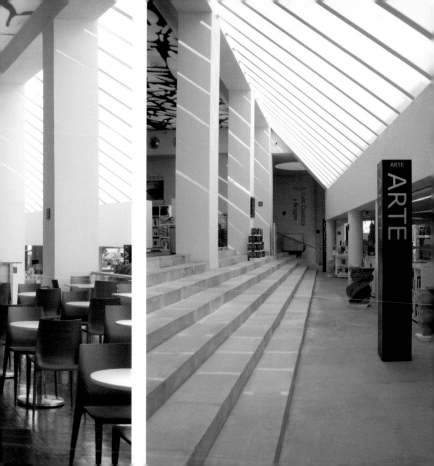

Showroom FUA

BH / Broissin y Hernández de la Garza
(Gerardo Broissin, Jorge Hernández de la Garza)

2005
CAD México, Av. Juan Vázquez de Mella 481
Polanco

www.fua.com.mx
www.broissinyhernandezdelagarza.com

A continuous, curvilinear structure characterizes this company dedicated to the sale and manufacturing of blinds. The program consists mainly in exhibiting and helping customers; the first point of contact between the visitor and the exhibition is a light rectangular glass structure defining its outline.

Ein durchgehender, kurviger Körper ohne Unterbrechungen charakterisiert dieses Unternehmen, das Rolläden verkauft und herstellt. Im Vordergrund steht die Ausstellung der Ware und der Kundenservice. Um den Kontakt zwischen dem Besucher und der Ausstellung herzustellen, fungiert eine leichte, rechteckige Glasverkleidung als Begrenzung.

Un corps curviligne sans interruption caractérise cette entreprise consacrée à la vente et à la fabrication de persiennes. Le programme consiste principalement à exposer et à servir les clients ; servant de premier point de contact entre le visiteur et l'exposition, une légère enveloppe de verre rectangulaire trace les limites.

Un cuerpo curvilíneo sin interrupciones caracteriza esta empresa dedicada a la venta y fabricación de persianas. El programa consiste principalmente en exhibir y atender a los clientes; como primer punto de contacto entre el visitante y la exhibición, una ligera envolvente rectangular de cristal traza los límites.

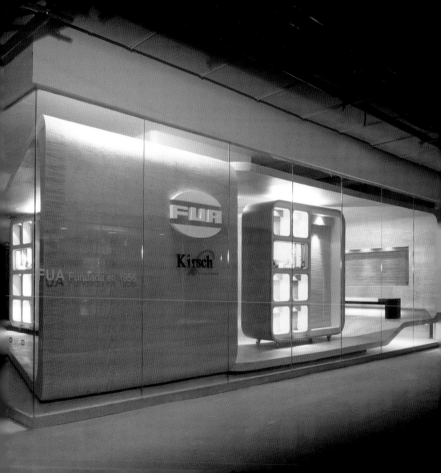

Piacere 2
Kitchen & Bathroom Showroom

Higuera + Sánchez

2002
Tennyson
Polanco

www.higuera-sanchez.com

This intervention converts a 1950s home in the Polanco neighborhood into a kitchen and bathroom furniture showroom with a contemporary design. A horizontal volume was inserted inside the original structure to create the main gallery that serves as the distribution and showroom floor.

Diese Baumaßnahme im Polanco-Viertel verwandelt eine Wohnsiedlung aus den 50er Jahren in Ausstellungsräume für moderne Küchen und Badmöbel. In die ursprüngliche Struktur wurde ein horizontales Gebäude eingefügt, um die Hauptgalerie zu errichten, die als Verkaufs- und Ausstellungsraum dient.

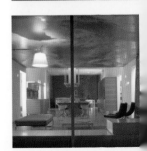

Cette intervention dans la colonie Polanco transforme un espace résidentiel des années 1950 en une salle d'exposition de cuisines et de meubles de salle de bains de conception contemporaine. Un volume horizontal s'intègre à la structure d'origine pour créer la galerie principale qui sert d'espace de distribution et de salle d'exposition.

Esta intervención en la colonia Polanco convierte un espacio residencial de los años 50 en una sala de exhibición de cocinas y muebles de baño de diseño contemporáneo. En la estructura original se insertó un volumen horizontal para generar la galería principal que funciona como el espacio distribuidor y sala de exposición.

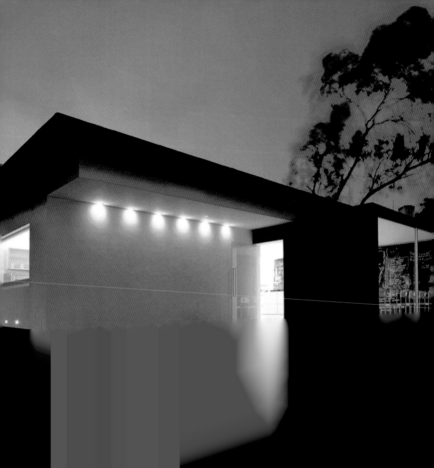

Antara Polanco
Business & Commercial Complex

Sordo Madaleno Arquitectos

2006
Ejercito Nacional S/N
Polanco

www.sma.com.mx

A mixed architectonic project was built (with offices, hotel and open-air commercial passage) where a General Motors plant was located for many years, consisting of 160 boutiques with the most internationally prestigious brands.

Dort wo sich viele Jahre lang ein Werk von General Motors befand, wurde ein Architekturprojekt mit unterschiedlichen Nutzungsmöglichkeiten, mit Büros, einem Hotel und einer Einkaufspassage im Freien errichtet, das aus 160 Markengeschäften mit internationalem Prestige besteht.

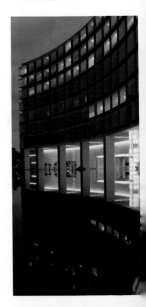

Là où depuis de nombreuses années se trouvait une installation de General Motors se dresse à présent un projet architectonique mixte (avec bureaux, hôtel et passage commercial à l'air libre), comprenant 160 locaux abritant des marques internationales prestigieuses.

Donde por muchos años se situaba una planta de General Motors se edificó un proyecto arquitectónico mixto (con oficinas, hotel y pasaje comercial al aire libre), conformado por 160 locales con marcas de prestigio internacional.

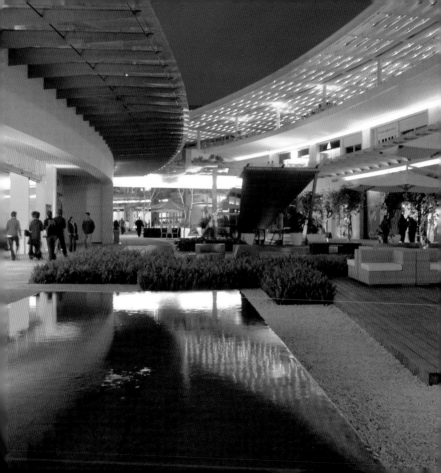

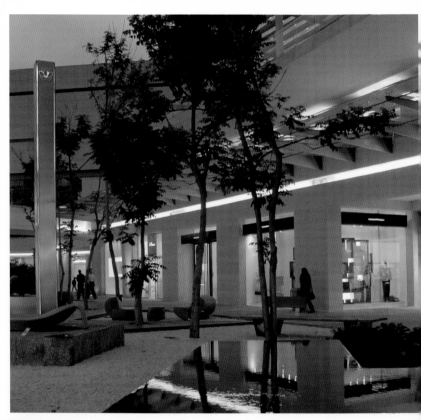

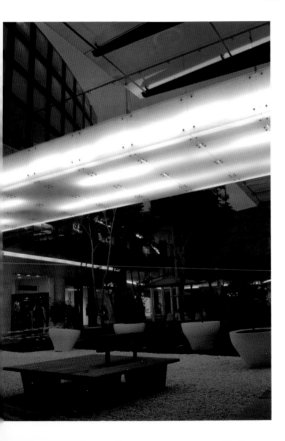

Palmas 530
Shopping Center

grupo arquitech, Arq. Juan José Sánchez-Aedo Liñero
Vidarq, Abraham Cherem Cassab Ades

2006
Av. de las Palmas 530
Bosques de Chapultepec

www.grupoarquitech.com
www.vidarq.com

A large glass box, which serves as a showcase window towards the avenue, arouses from the regeneration of a plot of land. The use of wooden mullions creates interesting shadow effects against the slanted planes of glass, giving the space dynamism and warmth.

Ein großer Glaskasten, der als Schaufenster zur Straße hin dient, entstand aus der Wiederaufbereitung eines Grundstücks. Die hölzernen Mittelpfosten der Fenster schaffen interessante Schattenspiele an den schrägen Glasflächen und geben damit dem Raum Dynamik und Wärme.

Une grande caisse de verre qui sert de vitrine donnant sur l'avenue naît de la transformation d'un lot. L'utilisation de meneaux en bois crée des jeux d'ombres intéressants sur les plans inclinés en verre, conférant à l'espace dynamisme et chaleur.

Una gran caja de cristal que sirve de aparador hacia la avenida nace de la regeneración de un lote. El uso de parteluces de madera crea juegos de sombras interesantes contra los planos inclinados de cristal, otorgándole dinamismo y calidez al espacio.

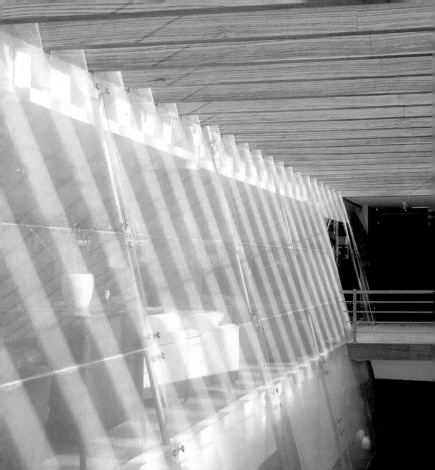

Parque Delta
Shopping Center

grupo arquitech, Arq. Juan José Sánchez-Aedo Liñero

2005
Av. Cuauhtémoc / Obrero Mundial
Narvarte

www.grupoarquitech.com

The use of orange-colored ceramic glass predominates as the principal theme of the space, giving a special character to the neutral handrails and stair landings. The panoramic elevators, which are lined entirely with the same material, act as a focal point, creating interesting lighting effects throughout the day.

Die Verwendung von orangefarbenem Keramikglas ist durchgängiges Gestaltungsmittel und gibt den neutralen Geländern und Treppenabsätzen einen besonderen Charakter. Die Panoramafahrstühle, die vollständig mit dem gleichen Material überzogen sind, dienen als Fokus und schaffen während des Tages interessante Lichtspiele.

L'utilisation de la vitrocéramique de couleur orange prédomine comme langage principal de l'espace, donnant aux balustrades et aux bases neutres un caractère spécial. Les ascenseurs panoramiques entièrement recouverts du même matériau jouent le rôle de centre de liaison, créant d'intéressants jeux de lumière tout au long de la journée.

La utilización del cristal cerámico en color naranja predomina como lenguaje principal del espacio, dando un carácter especial a barandales y pies neutros. Los elevadores panorámicos totalmente forrados del mismo material funcionan como punto focal, creando interesantes juegos de luz a lo largo del día.

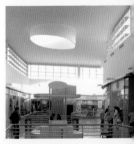

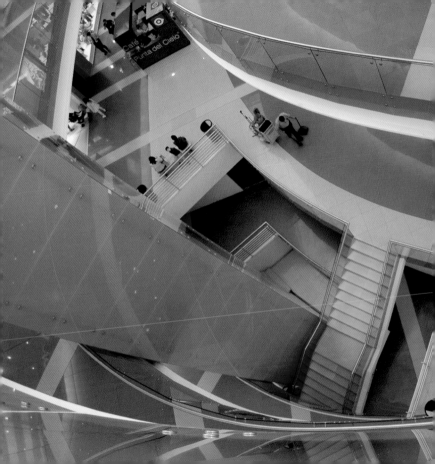

Index Architects / Designers

Index Architects / Designers

Index Structural Engineers

Index Structural Engineers

Index Districts

Index Districts

Photo Credits

Imprint

Copyright © 2007 teNeues Verlag GmbH & Co. KG, Kempen

Published by teNeues Publishing Group

teNeues Verlag GmbH + Co. KG
Am Selder 37
47906 Kempen, Germany
Phone: 0049-2152-916-0
Fax: 0049-2152-916-111
Press department: arehn@teneues.de
Phone: 0049-(0)2152-916-202

teNeues
International Sales Division
Speditionstraße 17
40211 Düsseldorf, Germany
Phone: 0049-211-994597-0
Fax: 0049-211-994597-40
E-mail: books@teneues.de

teNeues Publishing Company
16 West 22nd Street
New York, N.Y. 10010, USA
Phone: 001-212-627-9090
Fax: 001-212-627-9511

teNeues Publishing UK Ltd.
P.O. Box 402
West Byfleet, KT14 7ZF, UK
Phone: 0044-1932-403 509
Fax: 0044-1932-403 514

teNeues France S.A.R.L.
4, rue de Valence
75005 Paris, France
Phone: 0033-1-55 76 62 05
Fax: 0033-1-55 76 64 19

teNeues Iberica S.L.
Paseo Juan de la Encina 2-48
Urb. Club de Campo
28700 S.S.R.R. Madrid
Phone: 0034-657-132 133
Phone/Fax: 0034-91-659 5876

ISBN–10: 3-8327-9157-4
ISBN–13: 978-3-8327-9157-5
www.teneues.com

Bibliographic information published by Die Deutsche Bibliothek
Die Deutsche Bibliothek lists this publication in the Deutsche Nationalbibliografie;
detailed bibliographic data is available in the Internet at http://dnb.ddb.de

Concept of and:guides by Martin Nicholas Kunz
Edited by Michelle Galindo
Translation: C.E.T. Central European Translations GmbH
Layout: Michelle Galindo
Imaging & pre-press, map: Jan Hausberg, Martin Herterich, Vanessa Kuhn

fusion-publishing stuttgart . los angeles www.fusion-publishing.com

Printed in Italy

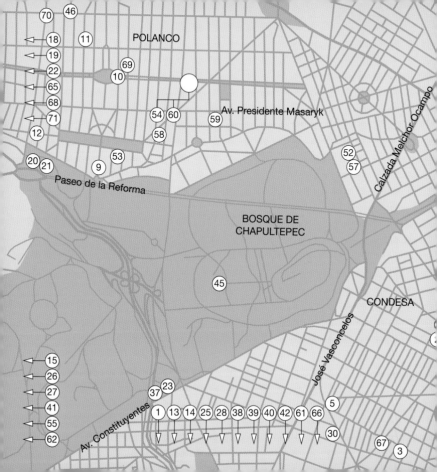

POLANCO

Av. Presidente Masaryk

Paseo de la Reforma

BOSQUE DE
CHAPULTEPEC

Calzada Melchor Ocampo

CONDESA

José Vasconcelos

Av. Constituyentes

Legend

AN RAFAEL

Paseo de la Reforma

ROMA

Ámsterdam

QUE
ICO

(44)

(24) (56)

(4)

(72)→

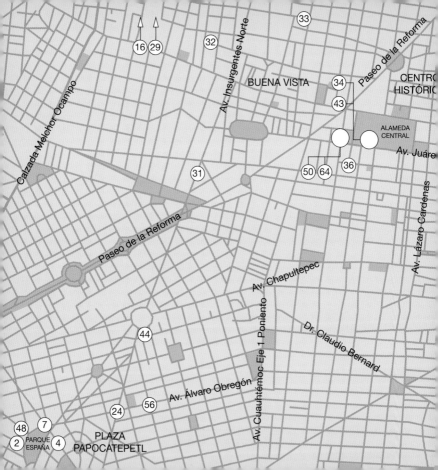

Legend

República de Chile

(51)

(35) (17)

PLAZA DE LA
CONSTITUCIÓN
ZÓCALO

(47)→

(8)

and : guide

Size: 12.5 x 12.5 cm / 5 x 5 in. (CD-sized format)
192 pp., Flexicover
c. 200 color photographs and plans
Text in English, German, French, Spanish

Other titles in the
same series:

Amsterdam
ISBN: 3-8238-4583-7

Barcelona
ISBN: 3-8238-4574-8

Berlin, 2nd edition
ISBN: 3-8327-9155-8

Chicago
ISBN: 3-8327-9025-X

Copenhagen
ISBN: 3-8327-9077-2

Hamburg
ISBN: 3-8327-9078-0

Hong Kong
ISBN: 3-8327-9125-6

London
ISBN: 3-8238-4572-1

Los Angeles
ISBN: 3-8238-4584-5

Moscow
ISBN: 3-8327-9156-6

Munich
ISBN: 3-8327-9024-1

New York, 2nd edition
ISBN: 3-8327-9126-4

Paris
ISBN: 3-8238-4573-X

Prague
ISBN: 3-8327-9079-9

San Francisco
ISBN: 3-8327-9080-2

Shanghai
ISBN: 3-8327-9023-3

Tokyo
ISBN: 3-8238-4569-1

Vienna
ISBN: 3-8327-9026-8

teNeues